SET UP
YOUR HOME STUDIO

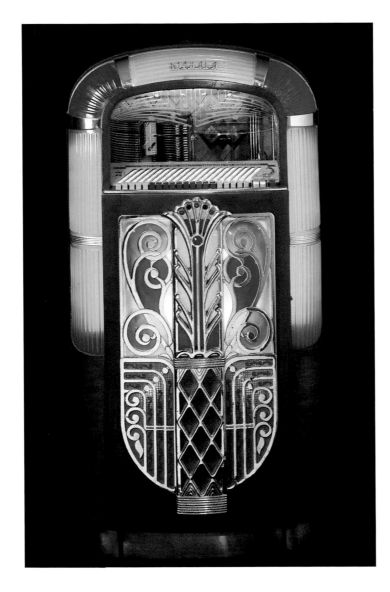

SET UP
YOUR HOME STUDIO

Published by Time-Life Books in association with Kodak

SET UP YOUR HOME STUDIO

Created and designed by Mitchell Beazley International
in association with Kodak and TIME-LIFE BOOKS

Editor-in-Chief
Jack Tresidder

Series Editor
Robert Saxton

Art Editors
Mel Petersen
Mike Brown

Editors
Louise Earwaker
Richard Platt
Carolyn Ryden

Designers
Ruth Prentice
Stewart Moore

Picture Researchers
Veneta Bullen
Jackum Brown

Editorial Assistant
Margaret Little

Production
Peter Phillips
Androulla Pavlou

Consulting Photographer
Michael Freeman

Coordinating Editors for Kodak
Paul Mulroney
Ken Oberg
Jackie Salitan

Consulting Editor for Time-Life Books
Thomas Dickey

Published in the United States
and Canada by TIME-LIFE BOOKS

President
Reginald K. Brack Jr.

Editor
George Constable

Set Up Your Home Studio
© Kodak Limited, Mitchell Beazley Publishers,
Salvat Editores, S.A., 1985

Library of Congress catalog card number 83-51659
ISBN 0-86706-237-1
LSB 73 20L 13
ISBN 0-86706-236-3 (retail)

Contents

6 Controlling the Image

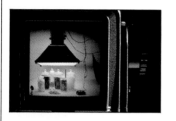

16 Your Own Studio

18 Planning the space
20 Sharing the space
22 The permanent studio
24 The specialist's studio

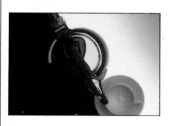

26 Studio Lighting

28 Tungsten lights
30 Electronic flash
32 One-lamp lighting
34 Multiple light sources
36 Enlarging the light source
38 Arranging the lighting/1
40 Arranging the lighting/2
42 Hard lighting
44 Soft lighting
46 Shadowless lighting
48 The daylight studio

50 Backgrounds and Sets

52 Plain backgrounds/1
54 Plain backgrounds/2
56 Textured and patterned backgrounds
58 Simple sets
60 Elaborate sets
62 Front and back projection
64 Captive sets

66 People in the Studio

68 Tightly framed portraits
70 Full-length portraits
72 Groups and pairs
74 Small children
76 Fashion
78 The nude

80 Still-Life in the Studio

82 Composition
84 Color
86 Transparent objects
88 Offbeat still-lifes
90 Small objects
92 Jewelry
94 Flowers and plants
96 Food/1
98 Food/2

100 Glossary 103 Index 104 Acknowledgments

CONTROLLING THE IMAGE

The essence of studio photography is control, both of the subject and of the way it is lit. The still-lifes and figure studies on the following nine pages all demonstrate the clarity and precision you can achieve in controlled studio conditions without any loss of vitality or sparkle.

Some amateur photographers think of a studio as the exclusive domain of the professional and imagine that the skills and equipment required are beyond their reach. In fact, mastery of light and background, as exemplified in the picture opposite, is a skill that anyone can perfect. As for space and equipment, a room with good daylight, some pieces of white cardboard and a tripod for your camera are all you need for a rudimentary studio. Portable flash or inexpensive photolamps extend the possibilities further. However, most amateurs will soon want to progress to small studio flash units for even greater control over the image.

Like a darkroom, a studio may be temporary or permanent, depending on the space you have available. But lack of space need never hamper your creativity. However modest your home studio, the techniques described in this book will enable you to produce high-quality images in which every element is planned and nothing is left to chance.

A wriggle of light twists around a wooden knob and a feather, and rises behind them in a bold crescent to create a cool still-life with a hint of Oriental imagery. The background is a piece of white cardboard with a crescent cut out of it and blue-gray tracing paper stretched over the front. A flash unit illuminated the cutout from behind; linked to this was another flash unit that provided diffused lighting from above. The photographer used a curved acrylic sheet to capture compressed reflections of the crescent and knob, visible in the bottom part of the frame.

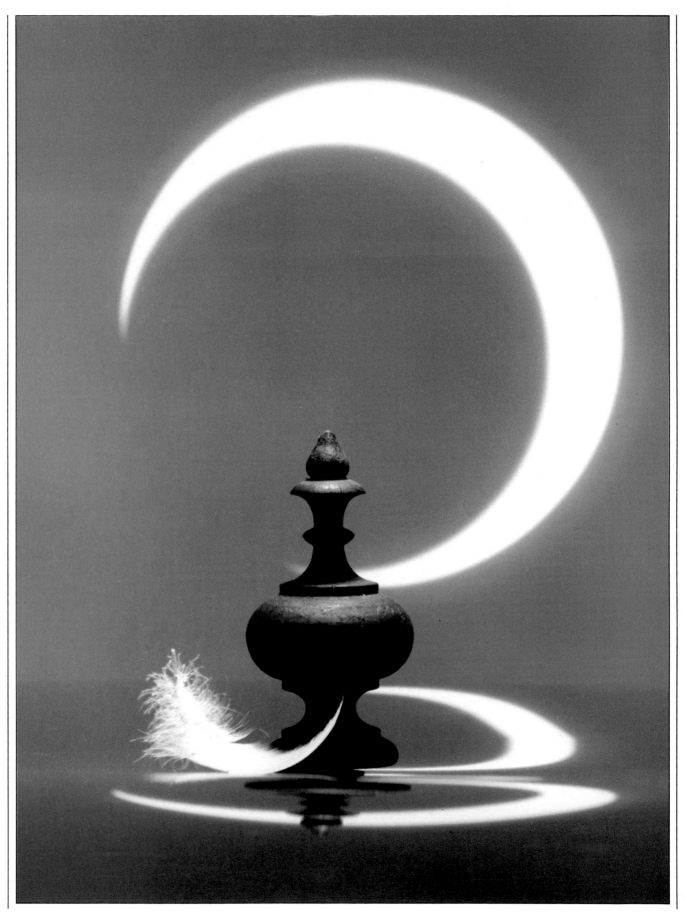

A plastic sandal and a bulb of garlic (below), faintly reflected in the sheet of red acrylic they stand on, make a memorable still-life with visually strong contrasts of color, form and texture, and of organic and man-made materials. The light source was a diffused photolamp angled onto the subjects from above. The lamp produced a reflected highlight on the toe of the sandal, the focal point of the composition.

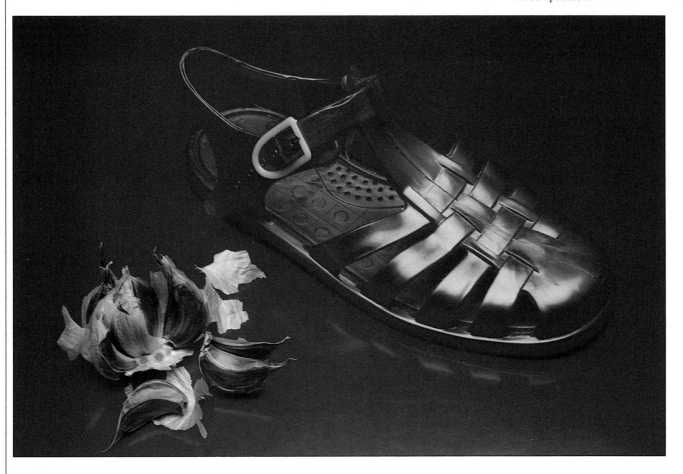

A glass of carbonated mineral water (right), containing an ice cube, a slice of lemon and a cherry, fills the frame with an image of thirst-quenching refreshment. A portable flash unit, aimed at a reflector immediately behind the glass, was quite adequate to light this small subject, and the burst of light was brief enough to freeze the motion of the tiny bubbles.

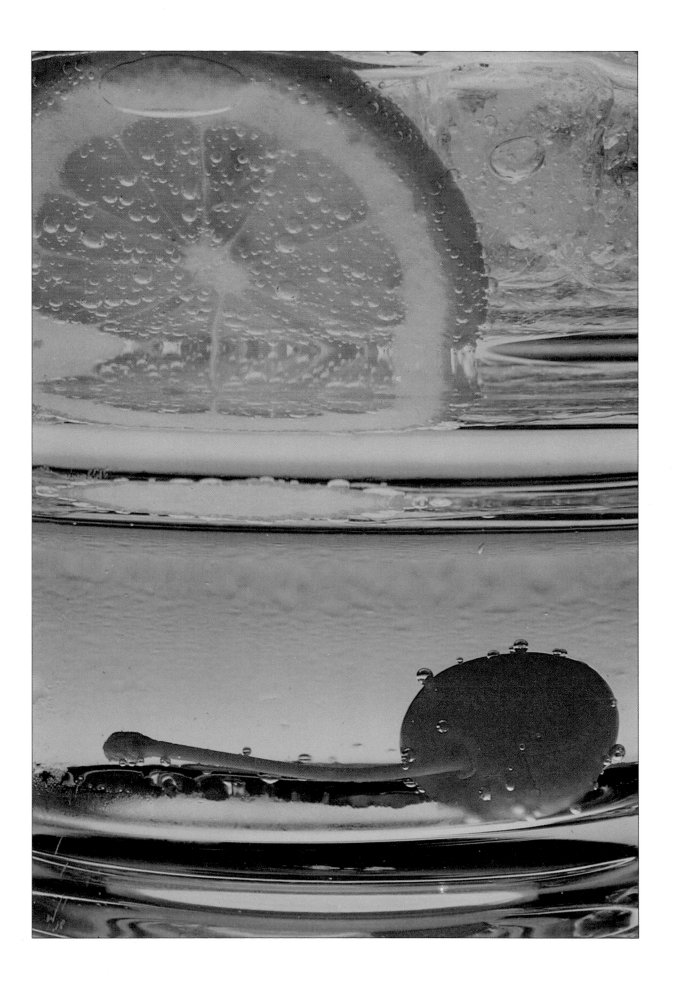

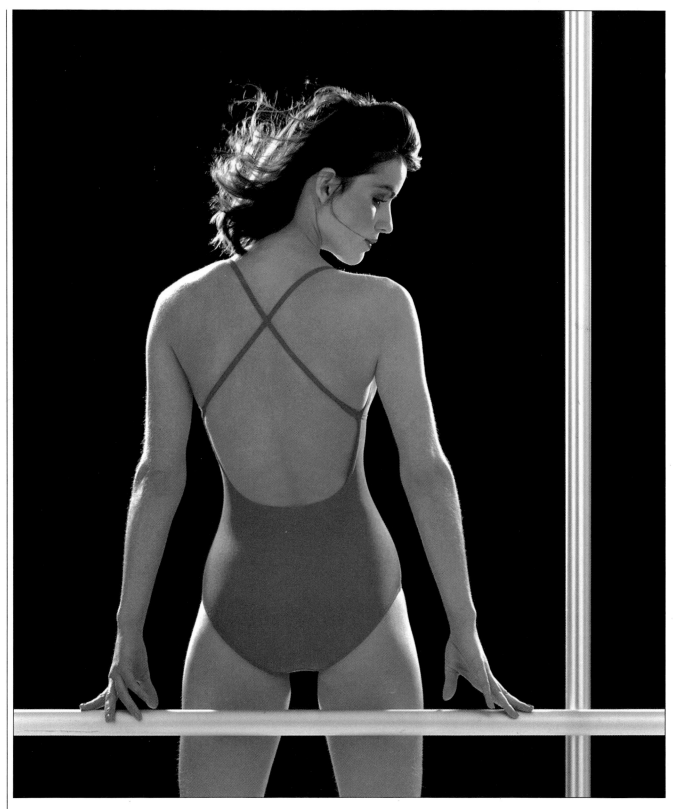

A model in a bathing suit (above) is rimlit by a pair of studio flash units, while a reflector above the camera provides fill-in lighting for her back. Her hair was gently lifted by an electric fan. The crossed poles provide balance in this simple composition.

A young girl (right) delights in her reflection in a large, free-standing distorting mirror. The girl was shy at first in front of the camera and all the equipment; but, as the photographer guessed, the novelty of the mirror soon dispelled her inhibition.

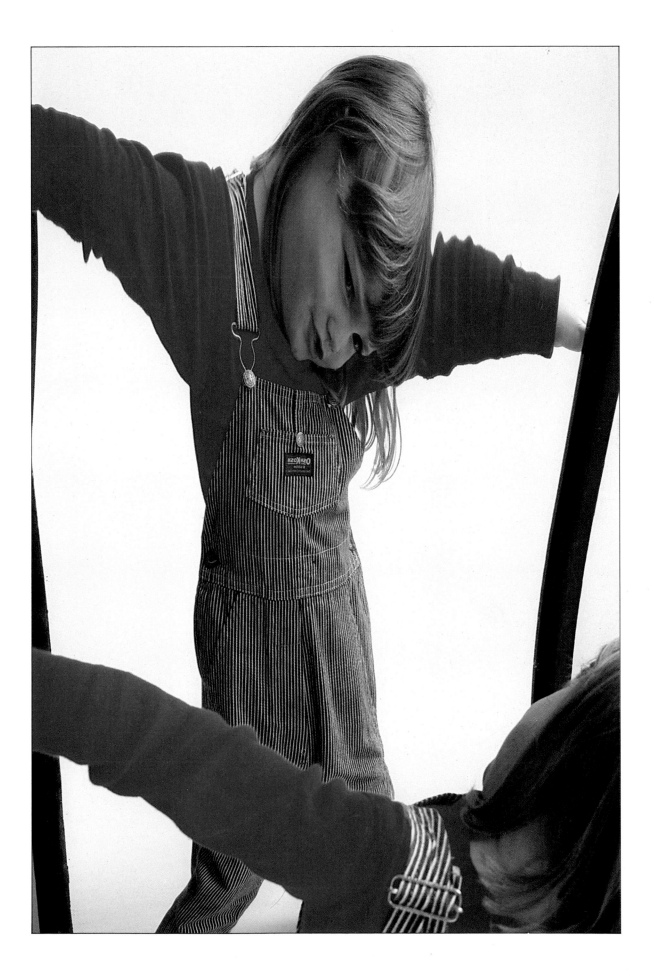

Shrimps (below) in a water-filled dish make an attractive close-up. A pattern of freeform swirls was formed by drops of oil added to the water. The photographer stood the dish on an acrylic sheet placed above an upturned studio flash, using a black paper mask around the dish to block unwanted light.

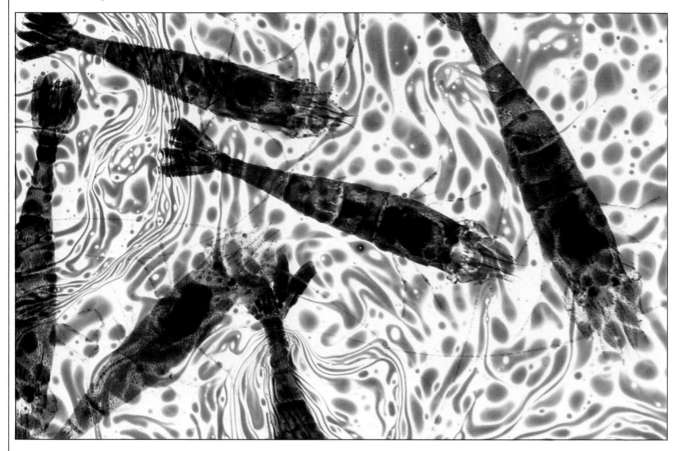

A still-life (right) based on Leonardo da Vinci's anatomical studies evokes the Dark Ages of surgery. The props were placed on an ancient operating table lent by a museum. To prevent shadows from obscuring details of the subject, the photographer used soft lighting from a flash unit with a square of translucent white acrylic sheet placed over it.

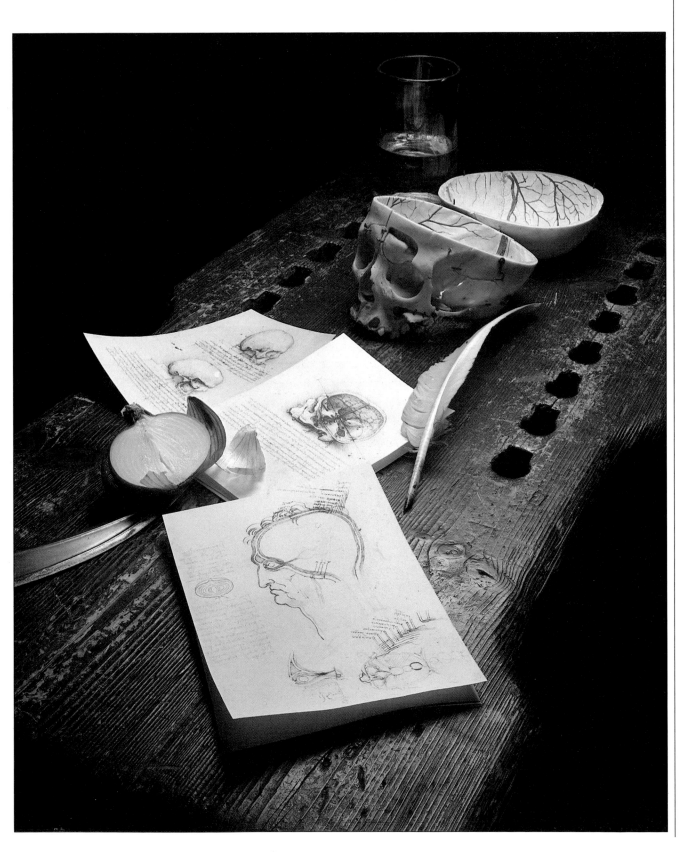

Sunlight and shade
*(left) add an overall
checkered pattern to an
unusual portrait of a woman,
whose bright red jumpsuit
matches the painted woodwork.
Instead of photographing the
model in his indoor studio,
the photographer moved
outside, using a lattice-
roofed carport as an
improvised studio annex.*

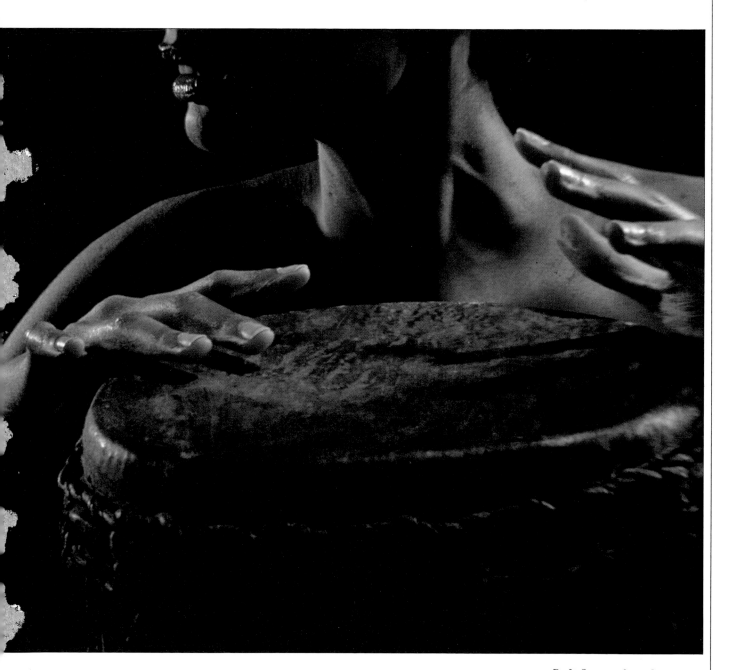

Deft fingers *beat the taut skin of a tribal drum. For this portrait, the photographer used a black velvet backdrop and backlit the drummer with a pair of studio flash units. A tungsten modeling light on each of the units let him preview the approximate lighting effect before taking the photograph.*

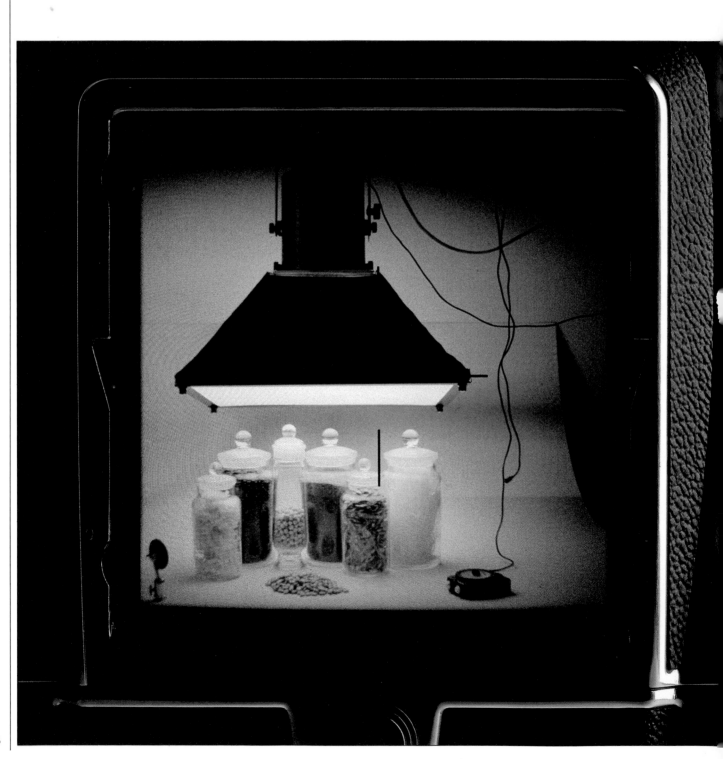

YOUR OWN STUDIO

Many photographers who would like to set up a studio are deterred by preconceived notions of what a studio should be like. In fact, studios are just as individual as the other rooms we live and work in. Certainly some big-city advertising studios are large and grandly equipped. But many of the sophisticated and impeccably professional images appearing in magazines are created in surprisingly modest surroundings. A good studio is simply one that serves your own individual needs, a space in which you can create your own style of pictures.

The following pages describe in clear, practical terms how you can design and set up a studio in whatever space is available to you. Whether you are converting a loft or making part-time use of a family room, start with a few pieces of basic equipment and let your studio evolve to suit your interests. Eventually, you may want to specialize in a particular area of studio photography, requiring more elaborate equipment like that shown in the setup for the food picture opposite. Accordingly, the last part of the section deals with the extra requirements for a specialist photographer's studio.

A food still-life, seen on the focusing screen of a medium-format camera, is surrounded by the equipment that the photographer will use when he closes in with a longer lens. The studio flash unit has a broad diffusing screen and tungsten modeling lights that go out when the flash fires. The small mirror at the left casts highlights on the glass jars. At the right is the flash meter.

Planning the space

The space you need for a studio depends entirely on the type of subject you plan to photograph. For modest still-lifes, a small spare room or a corner of a room are usually sufficient. However, if you are embarking upon studio portraiture, the space requirements are more exacting.

Ideally, the room should be large enough to let you frame a full-length figure using an 85mm lens, which is an excellent focal length for a flattering portrait. For head-and-shoulder portraits, a 105mm or 135mm lens can produce even better results. Long focal lengths can also be useful in still-lifes when you want to compress the perspective.

To frame a standing figure with a reasonable amount of background around the subject, an 85mm lens would demand a camera-subject distance of 17 feet (5 meters); in addition you would need an extra three feet (one meter) for maneuvering behind the camera and an extra four feet (1.2 meters) for the background setup. If necessary, you can generally make do with a shorter room – for example you may be able to position your camera in a neighboring room and take pictures through an open doorway. But the more usual alternative is to work with a 50mm lens or concentrate on head-and-shoulders views. The diagrams at the top of the opposite page will help you determine the limitations that your studio space will impose on your choice of subject matter and lens. Use them in conjunction with a scale plan of your studio, such as the one shown on the opposite page, below, to design the most convenient layout for your requirements.

Width is also an important aspect of studio design. To provide plenty of space for lighting units and for props and backgrounds, a studio should be at least half as wide as it is long. The scale model below shows a generously proportioned studio, with an adjacent darkroom and a special area reserved for dressing. However, most amateurs have to be content with less ample dimensions; again, you must find a reasonable compromise.

The height of the ceiling may also make a difference to the scope of your studio photography. A ceiling lower than nine feet (2.7 meters) will limit your lighting arrangements. On the other hand, if the room is higher than 12 feet (3.6 meters), it will be difficult to bounce light off a white ceiling onto the subject effectively.

Using space effectively

However large or small the dimensions of your studio, you should plan the best use of the available space in detail before putting up studio fixtures. The studio shown at right is used for a variety of subjects, but mostly for portraiture. The photographer made this model to help lay out a design that served his purposes most efficiently. He wanted to partition off a separate darkroom, both for home processing and for changing sheet film for his large-format camera. However, he decided to keep the darkroom small to allow space beside it in which models could dress or apply makeup.

1 Darkroom/film-changing room
2 Area for dressing and makeup
3 Storage area with shelves and cupboards
4 Main working space with permanent stands for rolls of paper background

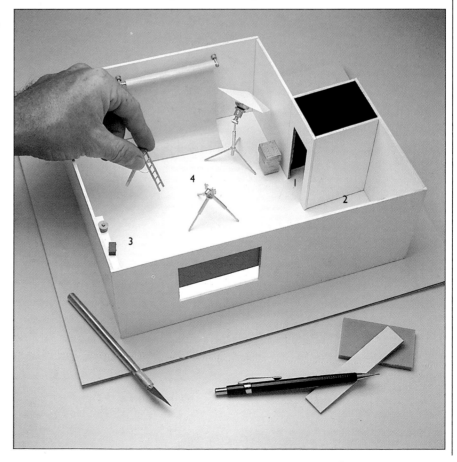

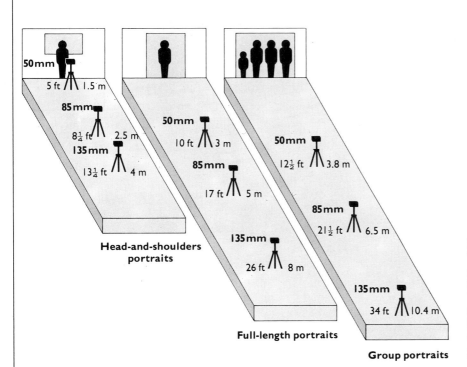

Head-and-shoulders portraits

50mm — 5 ft / 1.5 m
85mm — 8¼ ft / 2.5 m
135mm — 13¼ ft / 4 m

Full-length portraits

50mm — 10 ft / 3 m
85mm — 17 ft / 5 m
135mm — 26 ft / 8 m

Group portraits

50mm — 12½ ft / 3.8 m
85mm — 21½ ft / 6.5 m
135mm — 34 ft / 10.4 m

Lenses in the studio
The range of lenses you can use in a studio may be limited by the space available and the type of subject you wish to portray. The diagrams at left show the camera-subject distances required for different kinds of portraits when using one of three lenses with focal lengths particularly useful in studio photography.

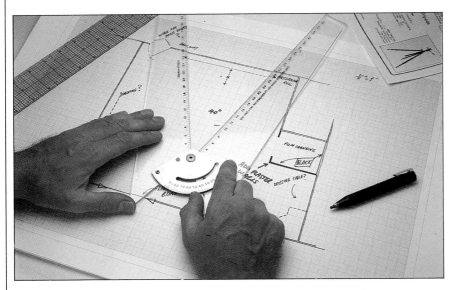

Planning a studio on paper
Drawing a scale plan of a studio on graph paper is an essential preliminary to designing the layout in detail. In the picture at right, a photographer is using an adjustable triangle to work out camera angles and camera-subject distances required for portraiture.

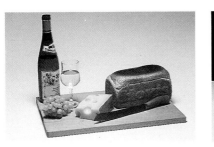
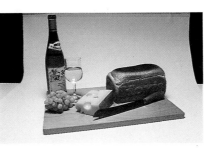

Angles of view
Lenses shorter than 50mm have a limited use in the studio because they often take in extraneous details. In the picture at far left, taken with an 85mm lens, the subject and background fill the frame. A 35mm lens from a closer viewpoint showed the subject the same size, but unavoidably included the edges of the background paper.

Sharing the space

Many homes lack a spare room, but few are without a room that can double as a studio. Amateur studio photographers can often work out time-sharing arrangements within a living room, bedroom, den, playroom or garage, depending on the space available and on the needs of the household. Moving furniture and setting up or dismantling lighting, backgrounds and props takes less effort than you might think, although storage can be a problem.

As the sequence of photographs on these two pages demonstrates, you can improvise a small portrait or still-life studio with a minimum of disruption by working against a wall or corner that is relatively free of furniture. Any furniture the space does contain can be pushed temporarily out of the way to another part of the room, or can even be used as a prop or support.

Unless you want a daylight studio, you need to find some way to darken the room. Obviously, this is much easier in a windowless space such as a garage. If you are using electronic flash in a room with windows, regular shades or curtains will block the daylight sufficiently. With tungsten lighting, you need to put up heavy dark curtains or black shades (as shown at the bottom of this page, right). Of course, such elaborate preparations are normally unnecessary for sessions taking place after dark.

Collapsible stands provide ample height for lighting units without causing undue storage problems. Alternatively, you can use space-saving spring clamps or screw clamps to attach lamps to furniture or the tops of doors. Always use pads with the clamps to protect paintwork.

Never use powerful or complex lighting setups without checking to make sure that you will not overload your circuit. Keep slack lighting cords neatly coiled and, if possible, hung above the floor on stands so that you cannot trip over them.

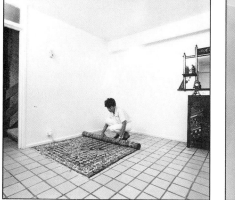

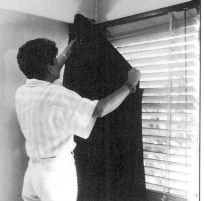

Making a temporary studio
The living room illustrated at left can be converted into a small, fully working studio in less than an hour. To clear the space, it is necessary to move only the vase, the table, the wicker chair, the plant and the rug (far left, below). The blinds are sufficiently lighttight for photography with electronic flash, but with tungsten lighting a thick black cloth has to be clamped in place over them (near left, below).

To turn the living room into the head-and-shoulders portrait studio shown here (opposite, above), the photographer used telescopic stands to support a white cardboard reflector and a flash unit with an umbrella reflector. A second unit, spring-clipped to the valance, enabled soft light to be bounced onto the subject off the white-painted ceiling and wall.

For the change to make a still-life studio setup (opposite, below) the photographer retrieved the round table to serve as a support for a sheet of white laminate used as a background. Plastic spring clamps prevented the laminate from slipping off the table. A flash unit with a large diffuser, suspended from an aluminum pole between two telescopic stands, provided overhead lighting, and a small mirror on an articulated stand supplied a precisely placed highlight. Against the wall, a piece of acrylic sheet stood by for use as an alternative background if required.

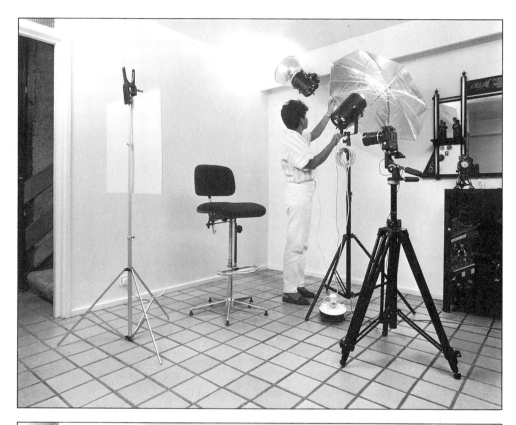

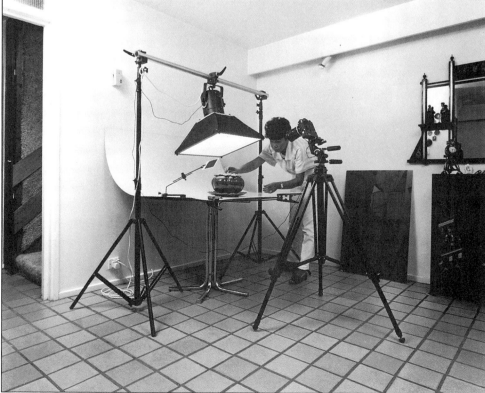

The permanent studio

Although temporarily converting a room into a studio is perfectly adequate for many amateurs, the ideal is a permanent studio amply outfitted to suit one's individual needs and preferences. The cutaway illustration here shows just one of many possible arrangements.

A photographic session can generate a certain amount of clutter, what with lights being set up, backgrounds, props and reflectors moved around, and sets being constructed. The most efficient studio is one that keeps clutter under control by having a regular place for every item when it is not in use. Avoid unnecessary furniture (although there should be at least one folding chair), and keep the floor space as clear as possible by using cupboards and the walls for storage. A pegboard is useful for hanging up tools, cables and other paraphernalia; you can keep track of everything that belongs on it by tracing an outline around each hanging object. To store rolls of background paper, build a lumber rack like the one shown opposite (12). Floor units, such as the equipment cart, still-life stand and light box shown here (16, 19, 20), should preferably be on wheels for maximum mobility.

Thick black shades are usually sufficient to exclude daylight. However, if you use wooden shutters instead, you can lean large flat items, such as backgrounds and sets, against them when wall space is restricted. The simplest type of shutter is a sheet of hardboard cut to fit the window frame and reinforced with wooden slats. When a room is completely shuttered, or when tungsten lights are used, good ventilation is essential.

Walls and ceilings should be mat white, since any other hue may add a color cast to your pictures. A smooth wooden floor is best; wood will take nails and screws, and you can place background paper over it and then walk on it without creasing the paper. Usually, special wiring is necessary only for tungsten lights exceeding three kilowatts.

1 Fire extinguisher	11 Hooks in ceiling for hanging backgrounds and lights
2 Electric fan	12 Storage racks for rolls of background paper and other materials
3 Work desk and stool	
4 Pegboard for tools, spring clips, tape and cables	13 Permanent stand for rolls of background paper
5 Wall troughs for nails, screws and other small items	14 Large mirror, useful particularly in portraiture
6 Refrigerator for storing film	15 Folding screen
7 Bulletin board	16 Equipment cart
8 Large cupboard for storing equipment	17 Wheeled stand for lighting units
9 Step ladder	18 Tripod-mounted camera
10 Plastic laminate, acrylic, polystyrene and hardboard sheets, diffusing screens, reflectors and other large flat items	19 Stand for still-lifes
	20 Light box for viewing slides
	21 Folding chair

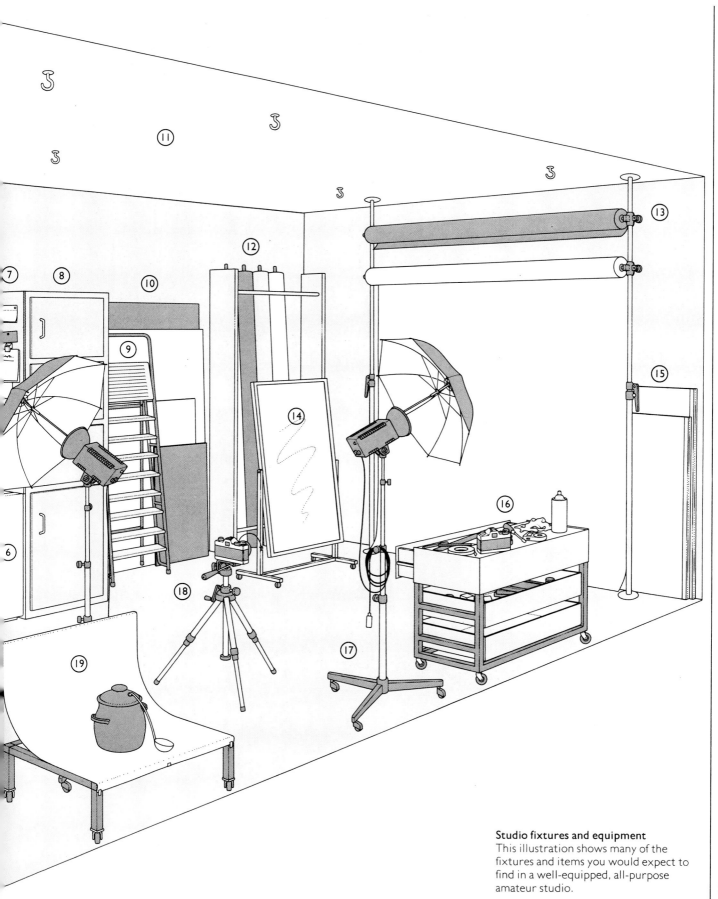

Studio fixtures and equipment
This illustration shows many of the
fixtures and items you would expect to
find in a well-equipped, all-purpose
amateur studio.

The specialist's studio

Professional studio photographers often concentrate on one kind of subject – for example fashion or food. Usually, such specialized work requires extra studio fittings, equipment or work areas, some of which are illustrated here. If you are interested in giving your own photography a professional-looking finish, you may want to consider equipping a basic all-purpose studio with similar additional features.

For fashion photographs, a prime requirement is a separate, adequately heated area where models can change and apply makeup. A theater-style dressing table like that shown opposite at bottom left, with a mirror surrounded by rows of naked light bulbs, is the most useful.

Food photography can be especially demanding in terms of studio layout. The ideal is a studio connected to a spacious kitchen. To keep cooked food looking freshly prepared right up to the moment you press the shutter release, or to show cooking processes, it is convenient to have a portable cooker in the studio itself. Some of the equipment often used in food photography is shown opposite, left.

Photographers who work for manufacturers of furniture, fabrics or floor coverings often make elaborate sets that create a complete domestic interior. Essential requirements are generous floor space and a high ceiling, as in the studio below. Space is also a key factor in studios that specialize in photographing large objects such as cars.

To eliminate expensive location work or to produce fantasy images, some photographers in advertising specialize in projected backgrounds. A front projection unit, like the one at top right on the opposite page, helps create a believable illusion.

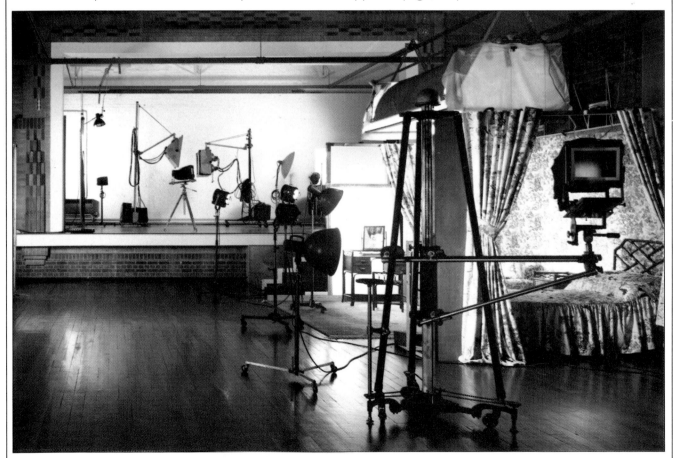

A spacious studio in *an adapted theater contains a large room set, with extra space for storage and set building. Overhead girders carry some of the lighting units.*

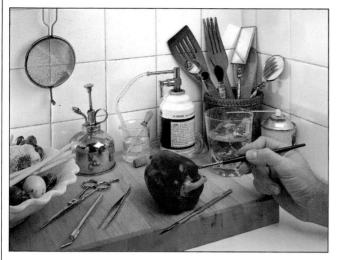

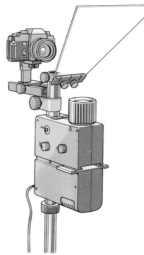

A front projection unit
The unit at left uses an angled, half-silvered mirror that projects a slide along the axis of the camera lens. A special screen placed in front of the unit reflects light back narrowly along the same path. This setup, described on pages 62-3, allows a model to stand in the light path without throwing a shadow onto the screen or reflecting any of the projected image.

Preparing food
Preparation of food for studio photography requires meticulous care. Food photographers use a range of equipment for ensuring that their subjects look appetizing. All the following items are shown in the photograph above:
Paring knife, craft knife and scissors; tweezers for removing hairs; water spray for freshening; pipette for adding water drops; aerator for adding small bubbles to liquids (green object behind capsicum in photograph); compressed-air can for larger bubbles; brushes for cleaning; mirrors for adding highlights; freezer spray to create condensation.

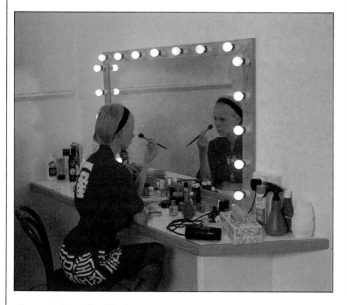

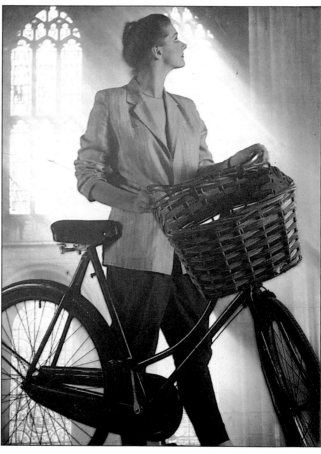

A model applies blusher in the dressing room of a fashion photographer's studio. The low-wattage tungsten bulbs on three sides of the mirror light the whole face evenly.

A woman with a bicycle stands incongruously in a cathedral – or appears to. This picture was actually taken in a studio using a projected background, as described at top.

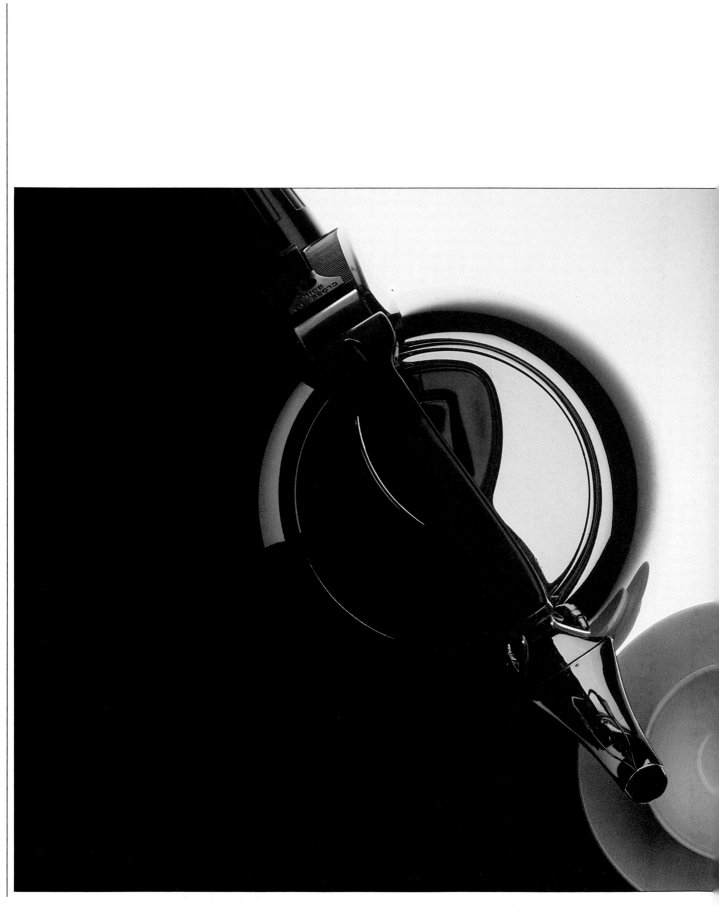

STUDIO
LIGHTING

Outdoors, photographers have to take the light more or less as they find it, and this makes the results difficult to control with any great precision. The sun's changing position constantly affects the quality of light; moreover, in seconds a passing cloud can turn brilliant sunlight into dull overcast.

With studio lighting you are immune to the vagaries of weather and time of day. You can use studio lamps to reproduce any lighting effect found in nature, and a good many more that sunlight could never create.

However, before you can realistically simulate the outdoor light of a sunny or a cloudy day, you must first understand exactly how light from different sources falls on the subject, and how you can moderate light by reflection and diffusion. The following section explains these basic elements of studio lighting, and shows how you can use them as building blocks to create illumination that is as natural, or as unreal, as you choose.

A shiny kettle reflects broad, diffuse studio lighting from one side, creating a symphony of curves in black and white. The photographer constructed the still-life on a glass-topped table, covering one half with black cardboard, and the other with tracing paper. Then he lit the table from below. Most of the light, though, came from a six-foot-high diffusing screen placed to the right of the camera and lit strongly from behind.

Tungsten lights

Choosing between two sources of artificial light, tungsten and flash, is an important decision. Some photographers use both types of light in the studio, but it makes sense to start with just one, if only for reasons of economy.

Tungsten light is the more familiar of the two and has distinct advantages for the beginner. Like the sun, a tungsten lamp is a continuous light source; therefore, you can see precisely what you are doing, and positioning lamps presents few problems. You can use your camera's meter to measure exposure; and if you wish, you can set a slow shutter speed to suggest movement, as in the picture below. Also, the simple construction of tungsten lights makes them inexpensive and reliable.

These benefits are all undeniable, but tungsten light also imposes some limitations on studio photography. First, the light is much yellower than daylight. This means that you cannot use daylight-balanced film in the normal way. Instead, you must fit a No. 80A filter over the lens or a similar filter over each light, or use tungsten-balanced film without filtration. Secondly, tungsten lamps get very hot, so you must take extra care when diffusing or reflecting the beam. Never place a lamp close to anything that can be damaged by heat. To keep the temperature down, use the minimum possible number of lamps – which sometimes may force you to use a wide aperture or put the camera on a tripod for a long exposure.

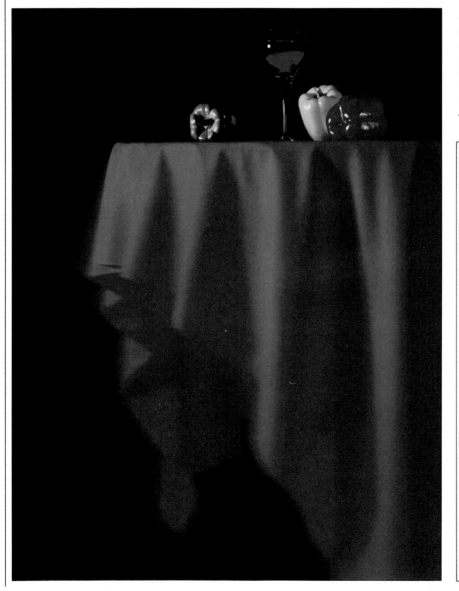

A red tablecloth blurred by slight movement gives a special beauty to a still-life photographed in tungsten light. The photographer created a draft by flapping a large square of heavy cardboard to stir the folds of cloth during the long exposure. Film balanced for tungsten light recorded the scene in its natural colors.

Photolamp

Tungsten-halogen lamp

Tungsten light sources
The cheapest tungsten lamps are photolamps. These resemble oversized light bulbs and generally have power outputs between 250 and 500 watts. They last for around 100 hours, but the beam from the lamp gets steadily redder and dimmer with use.

Tungsten-halogen lamps are more expensive but produce a more consistent light and have other advantages over photolamps: they are smaller, yet much brighter (500-2,000 watts); they give out more light for the same power consumption; and they last between two and 20 times longer.

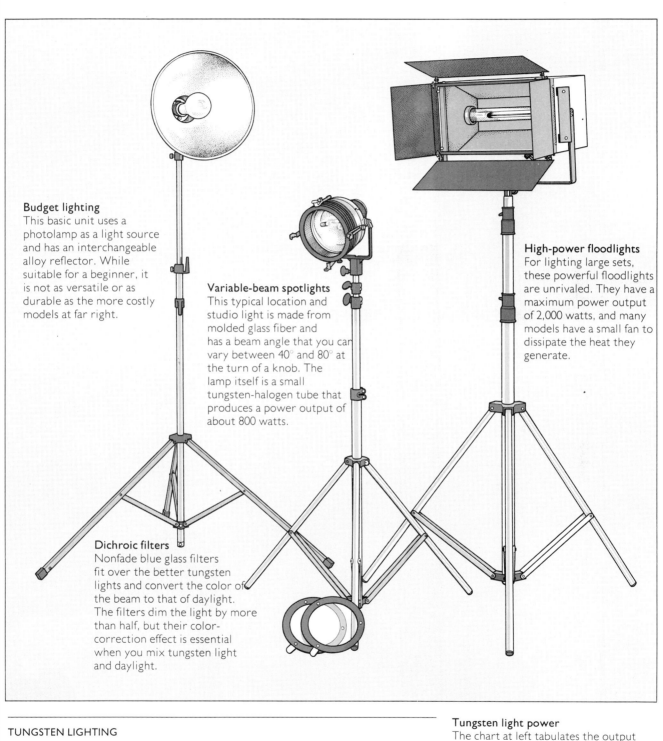

Budget lighting
This basic unit uses a photolamp as a light source and has an interchangeable alloy reflector. While suitable for a beginner, it is not as versatile or as durable as the more costly models at far right.

Variable-beam spotlights
This typical location and studio light is made from molded glass fiber and has a beam angle that you can vary between 40° and 80° at the turn of a knob. The lamp itself is a small tungsten-halogen tube that produces a power output of about 800 watts.

High-power floodlights
For lighting large sets, these powerful floodlights are unrivaled. They have a maximum power output of 2,000 watts, and many models have a small fan to dissipate the heat they generate.

Dichroic filters
Nonfade blue glass filters fit over the better tungsten lights and convert the color of the beam to that of daylight. The filters dim the light by more than half, but their color-correction effect is essential when you mix tungsten light and daylight.

TUNGSTEN LIGHTING

f-number	1.7	2	2.8	4	5.6	8	11	16	22	32
Reading lamp 60 W	●									
Budget tungsten lamp 275 W									●	
Variable-beam spotlight 800 W							spot ●-----● flood			
High-power floodlight 2,000 W										●

Tungsten light power
The chart at left tabulates the output of the tungsten lights shown above. The apertures in each case are those required for a shutter speed of 1/60, a film speed of ISO 100, with the lamp positioned 5 feet (1.5 meters) from the subject. A reading lamp is included for comparison.

29

Electronic flash

Studio electronic flash units operate in much the same way as their familiar camera-mounted cousins and share many of the same advantages. Both types produce a powerful daylight-colored flash of light that is brief enough to freeze movement, as shown below, without generating any heat. However, two qualities set studio flash apart from portable units – power and versatility.

Current from a line powers studio flash units, so light output is not limited by battery capacity. The power is usually measured in joules (or watt seconds) rather than guide numbers. The smallest studio flash units have a power output of about 100 joules; the largest, more than 20,000 joules. The most powerful camera-mounted flash, at 40 joules, seems puny by comparison. The chart at the bottom of the opposite page tabulates this information in terms of recommended apertures and distances.

Studio flash units give precisely equal amounts of light at each exposure; they do not regulate power according to subject distance, as do automatic portable flash units. So to judge exposure, you must use a special flash meter, as explained below.

To make the most of studio flash, you can use the units with a wide range of reflectors, diffusers and other attachments that modify the beam's softness and spread. To let you preview the effects of any changes you make, all studio flash units have a modeling light – a tungsten light that shows you the approximate effect of the lighting arrangement before you use the flash.

Even with this aid, it is not always easy to visualize accurately the effect of the flash, so many photographers use instant film in a special camera adapter, for a final check on composition, lighting and exposure. A further drawback to studio flash is its cost, which rises in proportion to the power of the unit. However, if these twin obstacles can be overcome, flash gives the freest rein to the studio photographer's skills and imagination.

A shower of confetti floats motionless, its movement arrested by the brief burst of light from a studio flash system. The photographer used two flash heads, directing one into a reflective umbrella to the left of the figure and lighting the blue backdrop with the other.

Flash meters

To set exposure when using flash, you must use a special meter. This reads *only* the pulse of light from the flash tube and ignores all other sources of light. Flash meters always measure incident light: to take a reading, you hold the meter close to the subject, with the diffusing dome pointed at the camera. On triggering the flash, a needle or digital display indicates the aperture to use, as shown below.

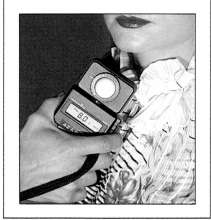

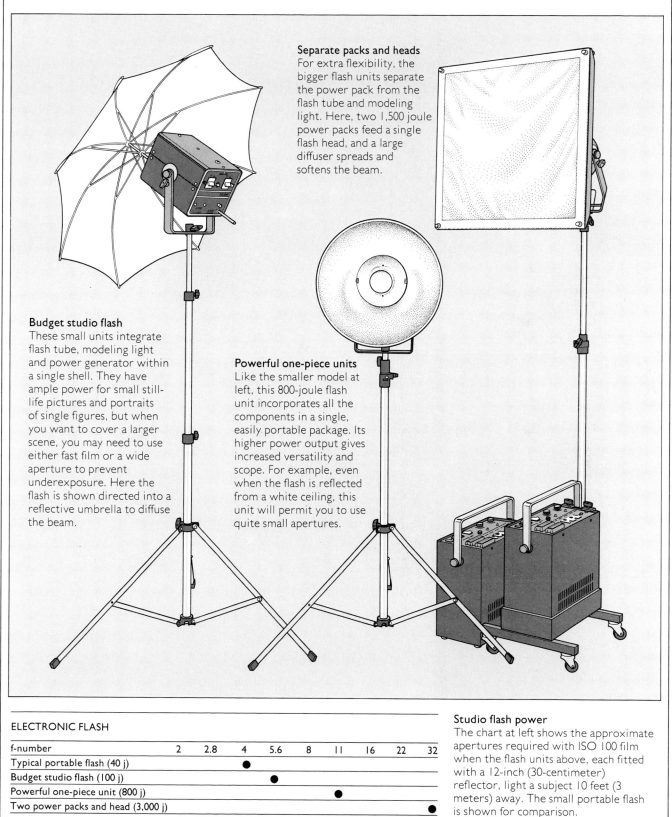

Separate packs and heads
For extra flexibility, the bigger flash units separate the power pack from the flash tube and modeling light. Here, two 1,500 joule power packs feed a single flash head, and a large diffuser spreads and softens the beam.

Budget studio flash
These small units integrate flash tube, modeling light and power generator within a single shell. They have ample power for small still-life pictures and portraits of single figures, but when you want to cover a larger scene, you may need to use either fast film or a wide aperture to prevent underexposure. Here the flash is shown directed into a reflective umbrella to diffuse the beam.

Powerful one-piece units
Like the smaller model at left, this 800-joule flash unit incorporates all the components in a single, easily portable package. Its higher power output gives increased versatility and scope. For example, even when the flash is reflected from a white ceiling, this unit will permit you to use quite small apertures.

ELECTRONIC FLASH

f-number	2	2.8	4	5.6	8	11	16	22	32
Typical portable flash (40 j)			●						
Budget studio flash (100 j)				●					
Powerful one-piece unit (800 j)						●			
Two power packs and head (3,000 j)									●

Studio flash power
The chart at left shows the approximate apertures required with ISO 100 film when the flash units above, each fitted with a 12-inch (30-centimeter) reflector, light a subject 10 feet (3 meters) away. The small portable flash is shown for comparison.

One-lamp lighting

The simplest of all lighting arrangements is a single lamp. Since the great advantage of studio photography is full control over lighting, working with just one light source may seem limiting. In fact, many of the best professional studio photographs have been taken this way.

Because one-lamp lighting is simple, it is less likely to distract attention from the subject. It also resembles daylight most closely, but without the variables of intensity and color that can make daylight difficult to handle. Used unobtrusively, as in the picture on the opposite page below, a single photolamp gives sympathetic, natural illumination that is particularly suited to informal portraits.

By lighting the background rather than the subject, you can produce such brilliantly outlined silhouettes as the one at the top of the opposite page. Or, by lighting from below through diffusing material, you can obtain dramatic images combining simple shapes with intricate detail, as in the picture below. The degree of diffusion and reflection also affects the image. If you use a large diffuser for side or frontal lighting, with a reflector to fill in shadows, you can supply broad, soft illumination that is subtle rather than dramatic. But take care that the lighting is not too even, or the result may be flat and uninteresting. And to avoid flare make sure that the light does not shine directly into the lens.

Luminous color and graphic shapes (right) combine in an unusual still-life composition. The subjects were placed on a glass surface two feet off the floor, with a photolamp beneath it. Tracing paper was taped to the underside of the glass to diffuse the light, which reveals translucent items in fine structural detail.

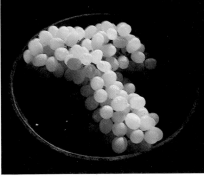

Droplets of water give a bunch of grapes (above) an appetizing luster. To create the pool of light on the subject, the photographer placed a photolamp behind the fruit bowl and used black cardboard (diagram, top) to prevent light from directly reaching the lens. The bowl's highlighted rim neatly encloses the subject.

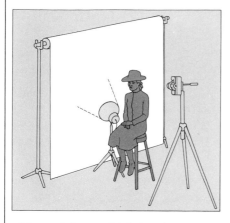

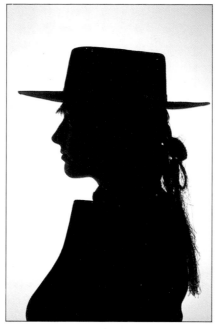

A hatted figure (right) makes an intriguing silhouette. The photographer posed the subject against a plain white backdrop, then angled a low photolamp up toward the background (above). The controlled lighting produced a perfectly clean-edged profile, which stands out sharply against the bright background.

A man concentrates on shaving (below), his face deeply shadowed by broad directional lighting. A large diffuser was placed in front of a photolamp set up directly to one side and about two feet away from the subject (diagram, above). The effect is close to that of natural light.

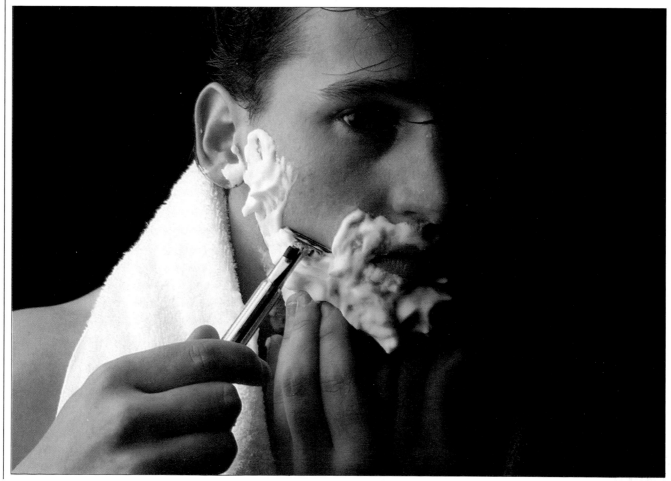

Multiple light sources

Introducing extra lights to support a main source opens up many creative possibilities in studio work. But multiple lighting needs to be organized with some thought. Too many lights, indiscriminately placed, may cast conflicting shadows and produce effects that merely look showy, competing with one another for attention instead of focusing interest on the subject itself.

The best way to avoid overcomplicated and unnecessary lighting is to begin by positioning the dominant light. Only then can you evaluate the function of extra lights properly. Add these one by one, making sure that each serves a definite purpose. If the setup requires extra lights to fill in shadows and reduce the contrast range, these should be introduced only when the main scheme is established and should always be understated. The picture below illustrates the point: a powerful, undiffused frontal

light here would have ruined the effect. Often, reflectors will lighten the shadows just as well.

Fill-in lighting frequently gives a softer, more flattering appearance to portraits and figure studies. However, for some subjects a contrasty treatment is much more suitable. In the portrait at the bottom of the opposite page, the areas of solid shadow make the image far more striking. This picture also shows the effectiveness of lighting a background separately to make the subject stands out and to avoid unwanted shadows on the background.

A light included for a particular effect, rather than for its contribution to overall illumination, is known as an effects light, and you should usually add this last of all. One example is a spotlight used to create a halo around the subject's hair, as in the picture below at left. Such special lighting can lend impact to a subject, as in the portrait opposite above.

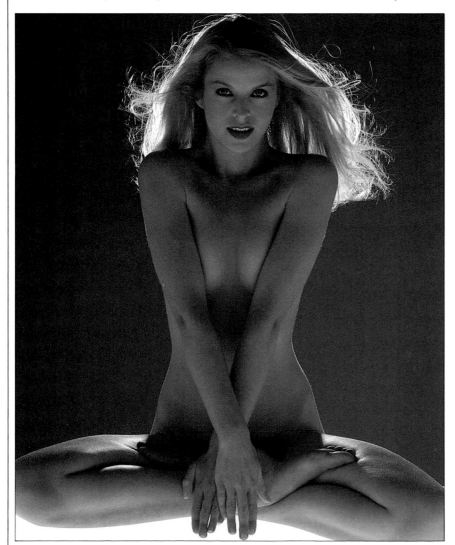

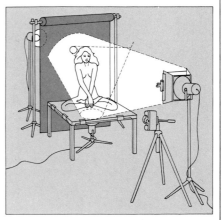

The symmetry of a nude pose (left) is enhanced by balanced lighting that emphasizes shape and color and casts a halo around the model's hair. The diagram above shows how the effect was achieved. The model was posed on a glass platform with tracing paper stretched across the underside to diffuse light from a photolamp beneath. Diffusing material placed over a fill-in light to one side of the camera gave soft modeling to the figure. A spotlight directed through a hole in the backdrop behind the woman's head provided the luminous halo effect.

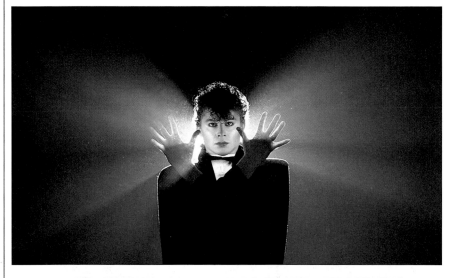

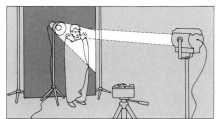

A caped figure (left) appears to radiate intense beams of light. To create the strongly theatrical mood, the photographer combined two light sources (above). A photolamp behind the subject brilliantly outlined the dark shape and gave the fingers a spectral translucence. The narrow beam of a spotlight, aimed directly onto the face, defined the features sharply.

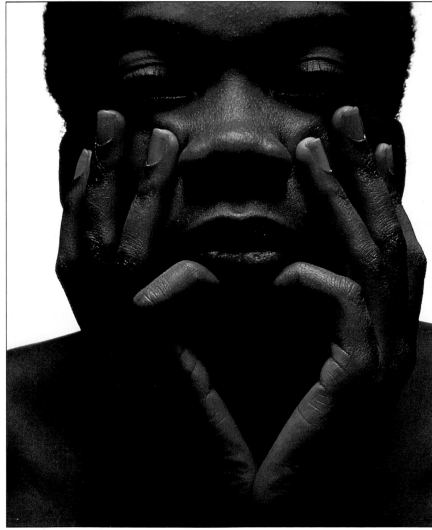

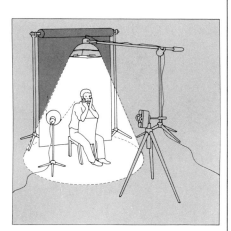

The rich tones and strong lines of a close-up portrait (left) are brought out by carefully controlled lighting (above). Diffused toplighting produced dense shadows without losing facial detail. A photolamp angled up toward the background gave clean, sharp definition to the subject. The photographer took an incident light reading from the face, and reduced the exposure setting by half a stop. Then he adjusted the lighting on the background so that it would be recorded overexposed by two stops. As a result, the background burned out to a creamy white.

Enlarging the light source

Skill in using photographic lights in the studio lies in learning how to manipulate the raw light source – the tungsten lamp or the electronic flash tube. These are small light sources and unless their beams are spread out by diffusion or reflection, they offer only the crudest illumination, creating hard shadows and small highlights on shiny surfaces, as in the picture below at left.

Harshly concentrated light in the studio tends to be used mainly for achieving special effects. For most other purposes, it is better to spread out the light. You can do this in one of two ways: by reflecting the beam off a white surface such as a piece of coated cardboard or styrofoam, or by diffusing the light through stretched white plastic sheet or fabric, or tracing paper.

When you direct light onto a reflecting surface or pass it through a diffusing material, the rays spread outward in all directions, effectively creating a light source many times larger than the small lamp that formed the original beam. The bigger the diffuser or reflector, then the paler and more soft-edged the shadows are and the more diffused the highlights.

When comparing pictures lit with large and small light sources, it is tempting to conclude that bigger is better, but in fact this is rarely true. As the photograph below at right shows, lighting that is too diffuse will eliminate shadows and highlights altogether, so that the subject's form and surface qualities disappear. The correct approach is to match the degree of diffusion to the subject, as in the picture on the opposite page. Here, the shadows are not harsh but are definite enough to show up the subjects' form and texture; the highlights do not glare but are bright enough to distinguish shiny surfaces from dull ones.

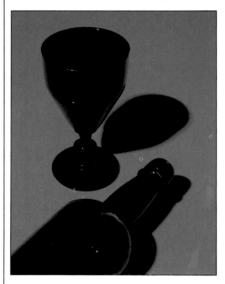

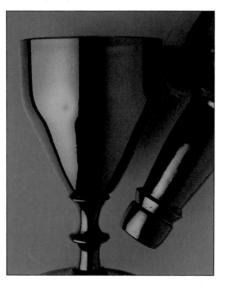

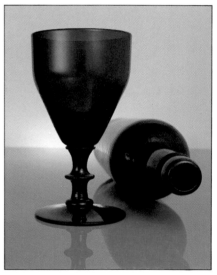

Small-source lighting
Lit only by a naked bulb, a bottle and glass appear as formless black shapes, highlighted with small spots of light. To reduce the size of the light in relation to the subject, the photographer moved the lamp back to a distance of five feet.

Medium-source lighting
A two-foot-square diffuser spreads the light beam, effectively creating a medium-size source of light. Placed on one side of the bottle and glass, this gave a much better sense of form. A reflector on the opposite side helped to soften and lighten the shadows.

Large-source lighting
To show the effect of extreme diffusion, the photographer surrounded the subject with tracing paper, then illuminated the paper from all sides. The result is a picture with dull, undefined highlights, and no sparkle or brilliance; the glassware has lost all its shine.

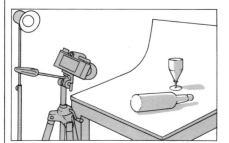

A study in white owes its subtle
yet definite shadows and highlights to
a three-foot-square diffused studio
light positioned above the table. Black
paper to the left of the camera helped
define the edges of the shiny objects.

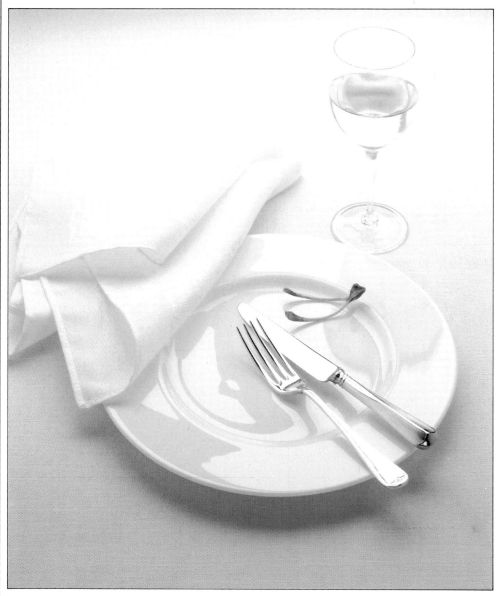

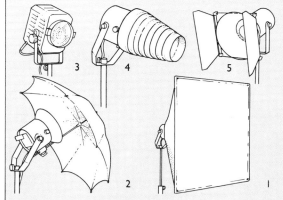

Changing the size of the light

To increase the size of the light, use
a diffusing attachment like a "window
light" (1), incorporating a translucent
acrylic sheet, or else direct the lamp
into an "umbrella" (2). Most umbrellas
spread the beam only by reflection,
but those made from white nylon can
also diffuse the light.

To reduce the size of the light, use
a focused spotlight (3), or mask down
the light source with a cone-shaped
shield, or "snoot" (4), or with
adjustable "barndoors" (5).

Arranging the lighting/I

The lighting arrangement plays a crucial role in determining how a subject will appear on film. In still-life photography, the general rule is to position the lights to bring out the most important qualities of the objects. For example, the bottom-lit picture on the opposite page, below, displays to best advantage the rich yellow translucency of the bottle of oil, which appears to glow with color.

Frontlighting, from a position close to the camera, gives strong colors and minimizes shadows; a slightly more oblique angle is preferable if you want to reveal form, as in the picture below at left. Side-lighting can give dramatic effects, particularly with upright subjects such as bottles, as in the still-life below at right.

Unless you are photographing a uniform subject, such as a collection of glassware, you may have to compromise over lighting direction. For example, in the picture opposite at top, backlighting records the bottles of liquids successfully, but disguises the form and color of the opaque items, which appear as graphic silhouettes. Often, you can get around such problems by using mirrors or reflectors, or by adding extra lights to the setup.

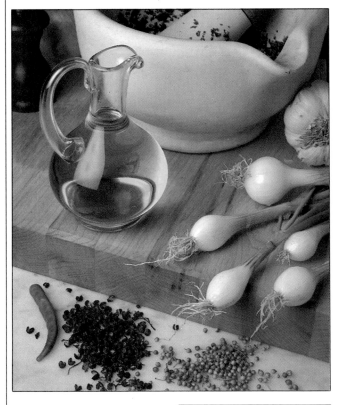

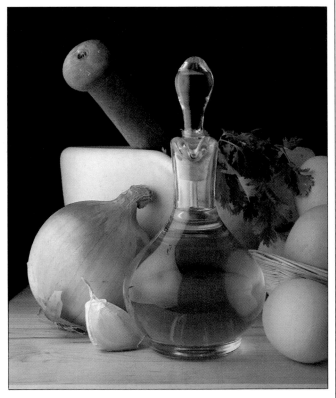

Frontlighting
With the main light source just to one side of the camera, details and colors are clearly rendered without serious loss of modeling, as shown in the still-life above. White cardboard angled onto the subject from the back provides fill-in lighting (diagram, right). The reflection in the bottle is the diffuser used to soften the light; it creates a highlight that adds interest to this composition and helps define the bottle's shape.

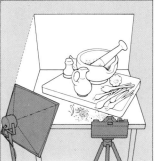

Sidelighting
Placing the main light directly to one side of the subject creates dramatic lighting, as exemplified in the still-life above. However, unless you want shadows to hide parts of the subject farthest from the light source, always place a reflector on the far side, facing the main light – as the photographer did here (diagram, right). Placing light-toned subjects on the dimmer side of the frame also helps ''lift'' the shadow areas.

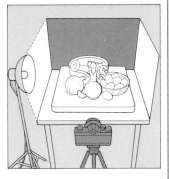

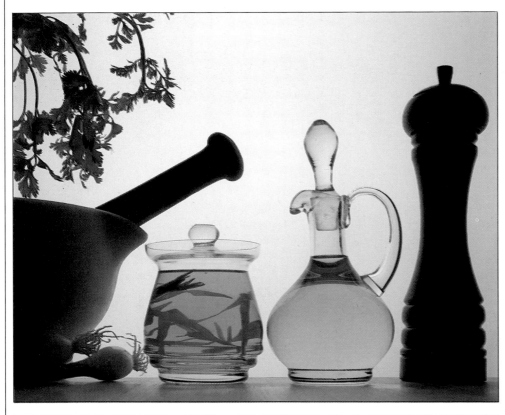

Backlighting

When the subject is opaque, lighting from behind, as diagrammed above, creates silhouettes. But with clear objects, such as the bottle and jar at left, backlighting emphasizes transparency and brings out the color of the contents. For a white, even tone at the back of the subject, diffuse the light thoroughly, using several layers of tracing paper or thick white plastic. Keep the light source well back from the diffuser.

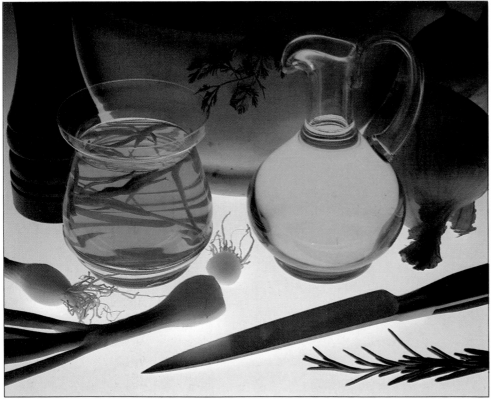

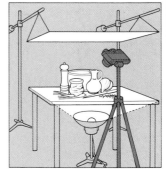

Bottomlighting

Because natural light very rarely comes from below, bottomlighting in a photograph has great impact. As demonstrated at left, bottomlighting can enhance the appearance of glassware, but, as with backlighting, opaque subjects will show as silhouettes. A white or silver reflector above the subject (diagram, above) will re-direct some of the light down onto the top of the still-life and help prevent this effect.

Arranging the lighting/2

In portraiture, the range of effective lighting schemes is much more restricted than with still-lifes. Many lighting configurations will yield an unflattering result. Devising an arrangement that does justice to the contours of the face and the tones and textures of skin and hair requires practice. As a first step, try a time-honored setup such as the one illustrated in the picture sequence here. You can then go on to experiment with variations on this theme and with more dramatic special-effects lighting, as described on the following pages.

The scheme shown uses three lights: one main light, one to illuminate the background and one more to add a highlight to the hair. Only rarely will you need more than three lights, and usually just one lamp will do. Avoid the temptation to overlight, or your portrait will look unnatural. For example, highlighting the hair is not vital for every portrait; it is essential only when the hair is very dark or is similar in color to the background.

Using foil reflectors is an excellent way to bounce light back into the shaded side of a face to lighten dark shadows. To avoid making the reflection too bright and losing the modeling altogether, crumple the foil. With color film, the darkest shadow should be no more than three stops darker than the brightest highlight. With black-and-white film, the latitude is four or four and a half stops.

A standard lighting scheme
The illustration sequence on these two pages shows how the photographer built up a standard scheme for a full-face portrait. As diagrammed at right, he used three lights, with reflectors to fill in unflattering shadows.

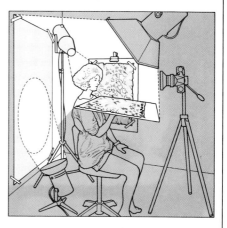

1 – Setting up a large photolamp with a diffuser over it provided the main light (left). This lamp, angled at 45° to the camera axis in both planes, lit the left side of the face but threw the other side into dark shadow. To prevent flare, the camera needed to be shaded.

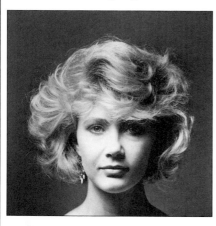

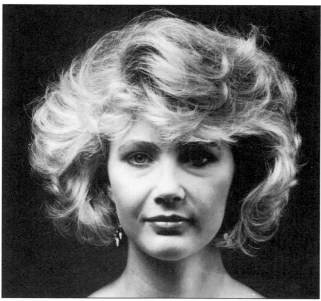

2 – Adding a foil reflector on the right of the face improved the effect by filling in some of the shadows. But there were still shadows under the chin and obvious folds of skin under the eyes.

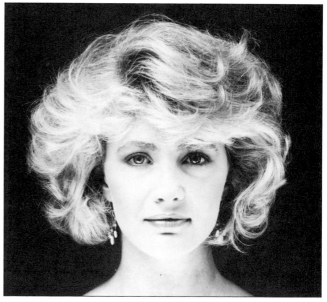

3 – Adding a second foil reflector beneath the face resulted in a more sympathetic effect. It removed the shadows from the neck and chin and improved appearance around the eyes.

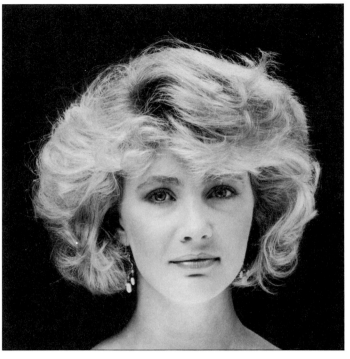

4 – Highlighting the hair by means of a snooted light, aimed at 45° downward onto the head from a position just behind and to one side, subtly improved the portrait. The effect with the snooted light alone is shown above.

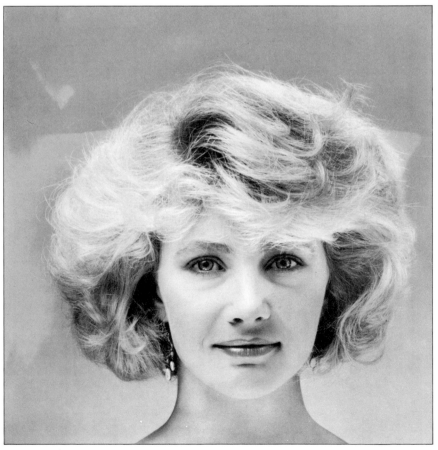

5 – Lighting the background, made of a sheet of warm yellow paper, completed the scheme. The light source was a lamp aimed upward from the floor behind the model's chair; this effect is isolated in the picture above.

Hard lighting

A small, undiffused light source casts deep, hard-edged shadows and creates sparkling highlights on any reflective parts of a subject. Such stark, uncompromising lighting is rarely flattering, particularly with portrait subjects; but used creatively and with discretion, hard light makes for bold, striking photographic images, such as those illustrated on these two pages.

Creating hard lighting is easy if you follow three simple rules: first, use a compact, nondiffused light source, such as a small portable flash unit, a focused spotlight, or a floodlamp masked down with a snoot; second, reduce the illuminated area by keeping the light source well away from the subject; finally, surround the subject with dark materials, such as black fabric or cardboard. This last step prevents reflected light from flooding into the shadows and reducing the overall contrast.

Because hard lighting produces high contrast, your camera's built-in exposure meter may be misled. Always base exposure on the brightly lit parts of the picture. To do this, move your camera closer to the subject until the highlights fill the frame, then take a meter reading before moving back to recompose the picture.

Hard lighting needs more careful positioning and organization than does soft lighting. If you move the light source or the subject just an inch or two, shadows will lengthen and spread across areas that were previously brightly lit. This can be disastrous when the picture's effect depends on the controlled interplay of dark and light tones, as in the photographs below and at right.

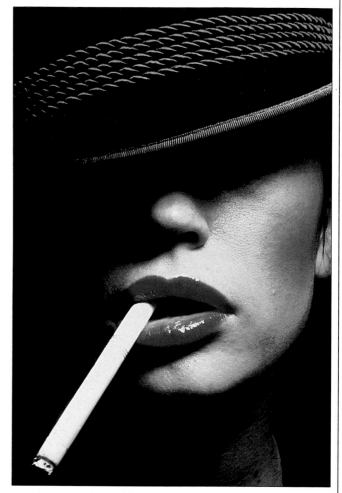

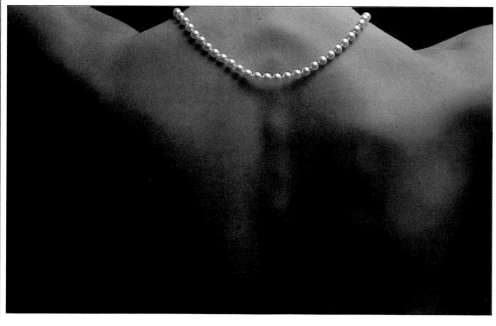

A severe portrait draws its power from hard sidelighting, which the photographer produced by directing a tungsten spotlight at the model's face. The exposure was based on the brightly lit cheek, so that the unlit side of the face fell in deep shadow.

Glistening pearls ring a woman's brightly lit neck. The hard, glancing light also exaggerates small undulations in the smooth skin below. To create this contrast of textures, the photographer positioned a single flash unit directly overhead.

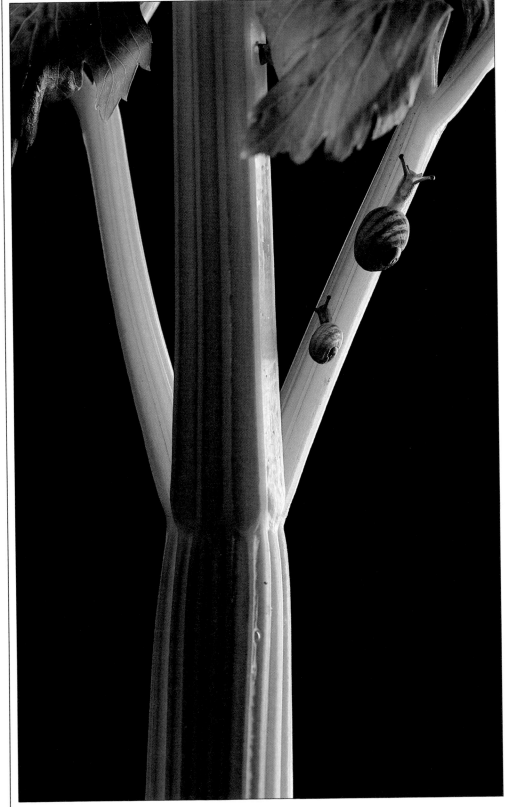

Snails seem to climb the branches of a tree in this cleverly framed close-up of a celery stalk. Hard light helps the illusion by removing any background clues to scale. Arranging a spotlight so that it backlit the snails emphasized their translucent qualities.

Hard light sources
You can create hard lighting from almost any light source if the lamp is far from the subject. But some light sources are specifically designed to form a hard, concentrated beam. Focused spotlights (1) are ideal, and a black snoot on a regular flood-lamp (2) is almost as good.

Soft lighting

Soft light casts a gentle pattern of light and shade across the subject, in marked contrast to the hard-edged shadows and glaring highlights that appear on subjects lit by a hard light source. For this reason, many photographers choose to diffuse the illumination from their studio lights, or to soften it in some other way — by reflecting the beam off a white-painted wall or ceiling, for example.

Reflective objects such as the bottle in the picture below benefit greatly from soft lighting. Because the shiny surface reflects a clear image of the surroundings, hard lights show up as ugly, burned-out spots. The reflections of soft lights are bigger and less glaring. Even so, the shape of the light source remains visible, so it is best to avoid using an umbrella reflector to diffuse the light, as the resulting

umbrella-shaped highlights may be obtrusive.

Soft lighting is also ideally suited to portrait photography, as the picture at the bottom of the opposite page shows. The diffuse lighting reveals the overall shape and bone structure of the face, yet helps conceal its lines and imperfections. To increase the softness of the light, you can either make the diffusing or reflecting surface bigger or move the subject and light closer together.

At the same time, bear in mind that beyond a certain point, softening the lighting ceases to improve the portrayal of an object's form and shape. For example, in the picture at right the shadows and highlights that give the skeins of wool modeling and solidity would virtually disappear if the light were diffused any further.

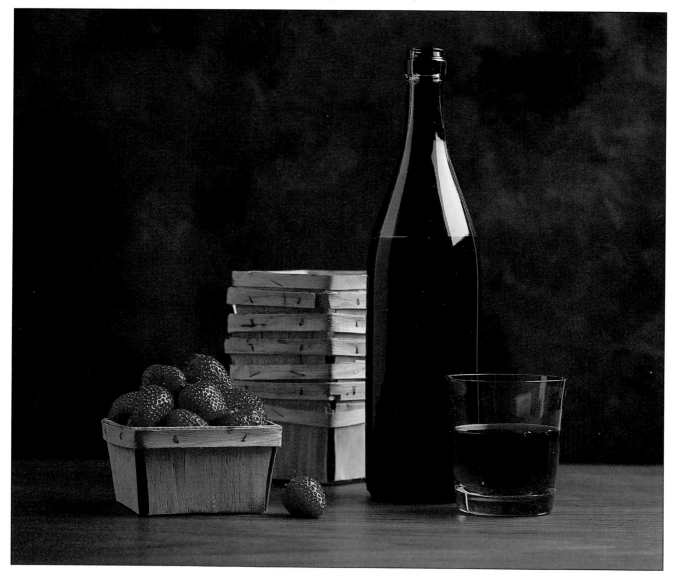

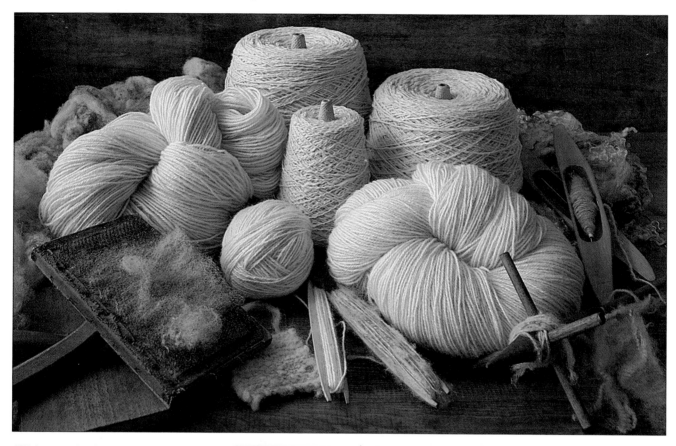

White wool (above) *looks naturally fluffy and soft in the reflected beam of a tungsten lamp. Directing the light at a white wall to the left of the picture softened the shadows and brought out the texture of the yarn.*

Fruit and wine (left) *offer contrasting textures, which soft lighting shows off to good effect. The photographer lit the still-life with electronic flash, placing a large sheet of white acrylic plastic in front of the flash head to diffuse the light.*

A downward glance (right) *angles a model's braided hair toward a diffused floodlight above her head. The soft light from this single source picked out every detail in her hair, and reflectors at her sides and across her knees softened the shadows on her pale skin.*

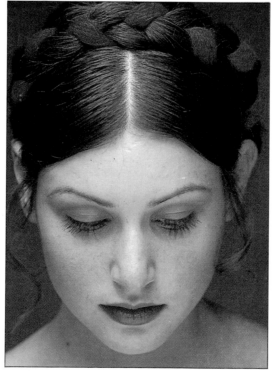

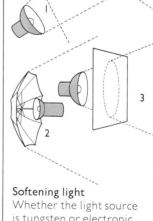

Softening light

Whether the light source is tungsten or electronic flash, you can use the same methods to soften its beam. The three simplest techniques are to shine the light onto a white wall (1), into a reflective umbrella (2) or through a diffusing sheet such as tracing paper or white acrylic plastic (3).

Shadowless lighting

By surrounding a subject with extremely soft light, you can create shadowless images. Because shadows connect objects to their backgrounds and settings, eliminating the shadows gives an airy, unreal effect, with subjects seeming to float in space.

Choosing a suitable subject is very important: one with predominantly dark tones will merely look flat and washed out in extremely high-key lighting. For the best results, most elements in the image should be white or pale-toned, with small areas of color to add interest. The picture below and the delicate portrait opposite are good examples. Portraits and full-length figures generally require extensive lighting: you need to surround the subject with comple-tely even illumination to remove the shadows cast by directional light. The diagram on the opposite page at top shows a typical arrangement. Each light source is diffused, bounced, or reflected to soften and spread the illumination. An alternative approach that works well with smaller-scale sets is to enclose the subject in a light tent – a cone or cylinder of white sheeting or other translucent material, which is then lit by photolamps from outside.

With shadowless lighting, the background should be slightly darker or paler than the subject to retain some definition. Take an incident light reading from the subject, and bracket exposures to ensure a satis-factory result.

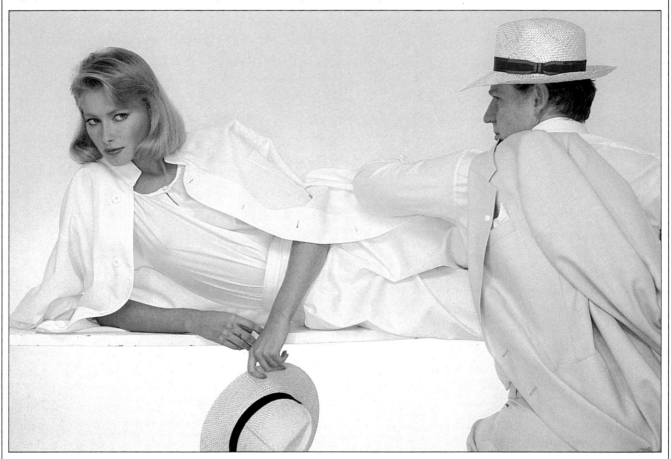

Cool sophistication (above) is established by diffused lighting that completely surrounds the white-clothed subjects. To judge the exposure setting, the photographer moved in close with his meter and took a reading from the woman's face.

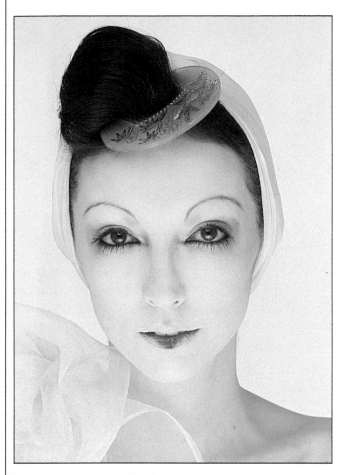

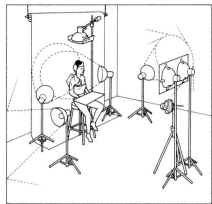

Exotic beauty (left) is conveyed by multiple lighting (diagram, above) that eliminates shadows. Diffused lamps above the camera provided the key light, with a lamp at either side of the model to bounce light off the white walls. The backdrop, a roll of white paper, was separately lit by two more lamps. A smaller lamp, diffused with tracing paper, was set up on a boom over the subject's head. The model held a piece of white cardboard that reflected light up into her face, removing shadows from under her chin.

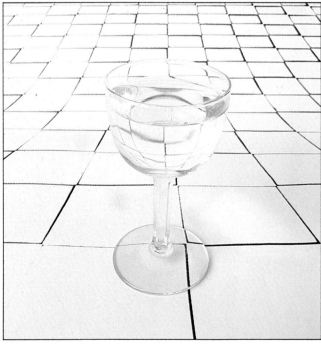

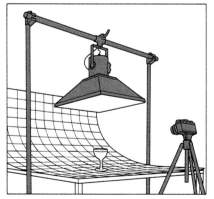

Milky light enhances the clarity of glass (above). The photographer placed the subject on a color photograph of a white tiled floor, which he curved to create a horizonless effect. A large overhead photolamp with diffusing material over it provided soft, flat illumination.

The daylight studio

A studio that lets you use natural light for your photography has a distinct advantage. For portraits and still-lifes, diffused daylight can be the very best choice: its soft luminosity reveals subtle details of color and texture, produces fine modeling, and flatters skin tones.

A loft with a large area of north-facing windows and skylights for toplighting can make an excellent daylight studio. Alternatively, a high ceilinged room with tall windows may be suitable. In the northern hemisphere, the advantage of using north light is that you avoid direct sunlight, which is too hard and contrasty. However, if you have a room that lets in an abundance of light, you can control the intensity by using blinds, curtains and other diffusing materials to soften and spread the illumination. White or pale walls and reflectors further help to spread the light. The picture at center shows a typical design for a daylight studio.

One problem with daylight is that its color temperature varies according to the weather and time of day. While direct sunlight has a color that gives neutral results with daylight-balanced film, different degrees of cloud, haze or blue sky may mean that you have to use warming or cooling filters from the No. 81 or 82 series to avoid a color cast. With color negative film, minor corrections can be made at the printing stage. But with color transparency film, you will have to learn by experience or buy a color temperature meter – an expensive but accurate aid.

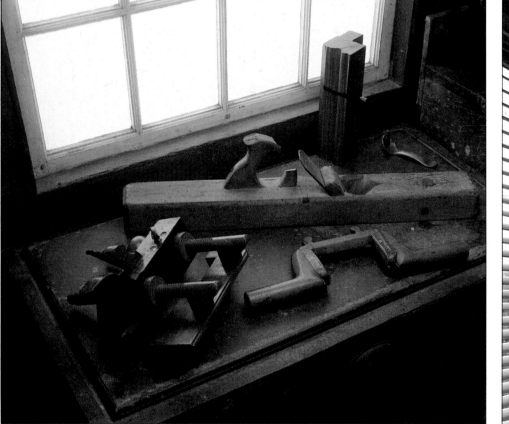

Traditional wood and metal tools create a harmonious still-life image. The interesting detail, and the subtle contrasts between tones and textures, made diffused sunlight the ideal type of lighting. The photographer arranged the objects next to the window, angling them to catch the light, and taped tracing paper over the outside of the window frame.

A head-and-shoulders portrait (left) reveals the special qualities of natural lighting. Diffused three-quarter light from a window and toplighting from a skylight provided even illumination around the subject. A reflector on the other side prevented part of the figure from being in shadow. The patterned backdrop provided a contrast with the plain colors and textures of the model's skin and clothing.

A classic still-life arrangement (above) derives freshness and sparkle from the varied shades of a single color, each faithfully recorded by natural light. The fruit and vegetables were arranged on a table to catch the sidelight through a window. Highlight and shadow on the peppers, farthest from the light, accentuate their shapes and glossy skins.

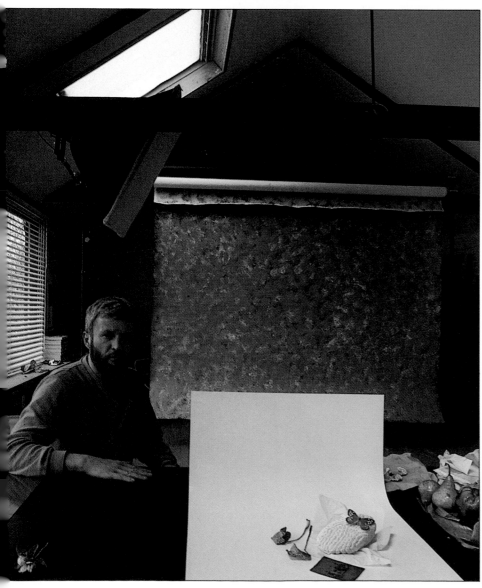

A well-designed daylight studio has large windows the length of one wall and a skylight in the sloping roof. The venetian blinds offer a means of controlling the intensity of window light. A selection of backdrops and table surfaces gives the photographer a variety of settings to suit different subjects.

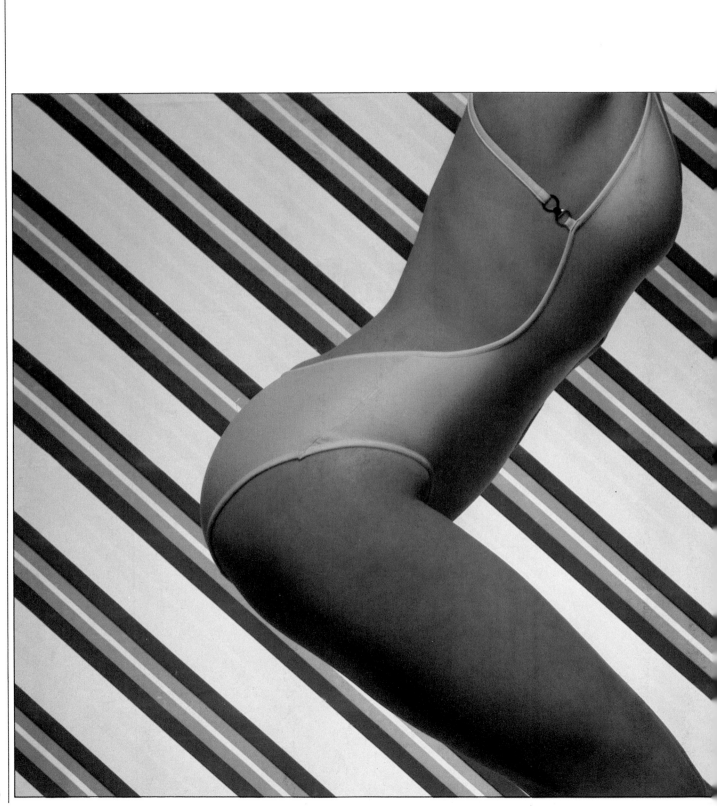

BACKGROUNDS AND SETS

One of the most exciting aspects of studio photography is scene-setting. With ingenuity and basic practical skills, you can transform the most modest studio space into an endless variety of sets, each individually designed for a particular subject. At its simplest, the setting may be no more than a plain backdrop, carefully lit to show a subject at its best. Taken a step further, the background may be patterned or textured to echo qualities in the subject, or to provide a bold contrast. In the picture at left, the background design is an integral part of the energetic composition. Projected backgrounds can be used to suggest an exotic location or a fantasy scene.

By building three-dimensional sets with flats and props, you can create the illusion of whole environments: a clinically modern interior one day, a French café the next. And because the set need extend only to the edges of the viewfinder frame, the most elaborate scenes can be surprisingly easy to create. The following section explains how to use backgrounds, build sets and arrange props, on both large and small scales, to obtain convincingly realistic or dramatically unnatural effects.

Diagonal stripes lend streamlined movement to a lithe figure. The picture shows how matching the style of subject and background – here a roll of wallpaper – can produce a thoroughly professional-looking shot.

Plain backgrounds/1

By choosing a plain background when composing a picture in the studio, you can show off the shape, texture and tones of a subject to their best advantage. Often you will be able to use one of the studio walls. However, for greater flexibility there is a wide range of commercially available colored background papers, sold in long rolls nine feet ($2\frac{3}{4}$ meters) wide. These are ideally suited to full-length portraiture. Instead of a neutral color, it is sometimes better to choose one that complements the hues of the main subject, as on the opposite page at top, or one that contrasts with the subject.

Making a paper background completely featureless demands care in hanging and lighting, as wrinkles in the paper can cast obvious shadows. The

simplest way to hang paper is to cut off a sheet the size you need and tape it to a wall. A better method is to thread a pole through the hollow cardboard core of the roll and mount it horizontally about eight to ten feet above the floor on a pair of vertical stands, as in the juggling picture opposite at left. Alternatively, you can suspend the pole from hooks screwed into the ceiling. For use, the loose end of the roll is simply pulled down to the floor and taped in position. By pulling down extra paper in a gentle sweep to the floor you can create a horizonless effect. If you mount three or four rolls of paper on one set of stands you can switch backgrounds easily. Because background paper soon becomes scuffed or creased, you may need to cut off the used portion

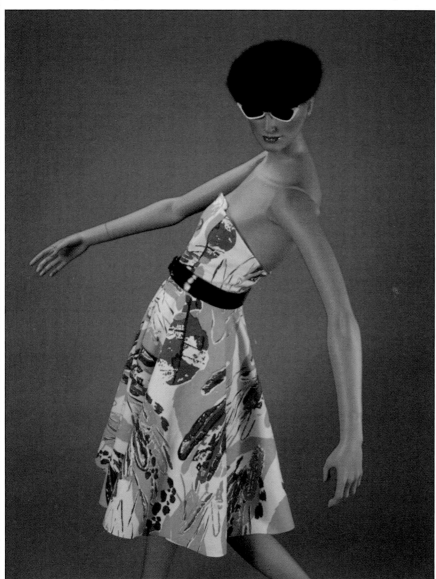

A mannequin (left), dressed for summer, stands in a jaunty pose against a backround of blue paper. To light the background evenly, the photographer used two flash units and placed the separately lit figure just in front of the intersection of their beams, as diagrammed above.

and discard it after one or two sessions.

Unless you want to use shadows creatively, as in the fashion photograph below at right, you should generally light a background separately from the subject. This allows you to use colored gels over the lights to change a white background to any other hue. For completely even tones, professionals often use two vertical striplights shaped like narrow troughs, each outfitted with a diffuser. However, lights of this design are expensive. Instead, you can use two lights aimed diagonally at different halves of the background, with the subject just forward of the point where the beams cross, as demonstrated on the opposite page. Better still, use four lights, one close to each corner of the background.

Shades of red (below) dominate a softly lit portrait. The photographer lit the red paper background separately with an upward-aimed electronic flash unit at ground level.

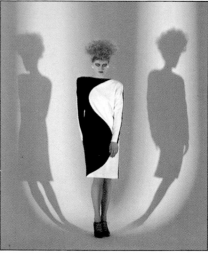

Curving shadows (above) frame a woman in a black-and-white dress. Two spotlights on either side of the camera threw the shadows onto a roll of white background paper pulled down in a long sweep to the floor. The spotlights were masked to confine each beam to an oblong.

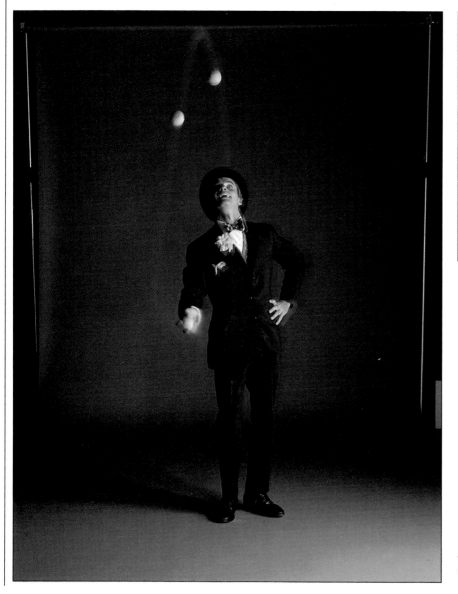

A juggler (left) demonstrates his skill against a gray background that complements his dark suit. The edges of the frame have been left uncropped to show the background setup – a roll of gray background paper supported on poles fixed between the studio floor and the ceiling.

53

Plain backgrounds/2

The choices of background material are wider for still-lifes than for portraits, because it is seldom necessary to cover such a large area. However, because still-life backgrounds are seen in close-up, even small blemishes are instantly noticeable; thus, compositions must be set up with great care. The texture of a paper background is usually apparent in the photograph, especially if the lighting is oblique – an effect that you can often use creatively. Choose fine-quality coated paper, with frontal lighting, for a smooth background, as in the picture below at right; or choose black velvet to concentrate even more attention on the subject.

Plastic laminate and acrylic sheet (such as plexiglass) are excellent still-life backgrounds, because with judicious lighting their smooth surface appears to be without depth. Both are available in a range of colors. Plastic laminate is ideal for horizonless backgrounds on a small scale. Simply clamp one end of a sheet to a table edge and allow the laminate to sag with the other end up against a wall. Acrylic sheet is less flexible and scratches easily, but its excellent reflective quality, shown in the composition on the opposite page below, makes it very useful. Moreover, translucent acrylic sheet can be backlit, as in the picture opposite above. A major disadvantage of acrylic sheet is its cost. As a substitute you can sometimes use a sheet of glass placed over colored paper, although anything reflected in the glass will show as a double image.

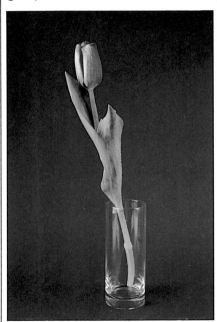

A tulip (above) rises elegantly from a straight-sided glass. The curve of the blue background paper, separately lit by electronic flash, was adjusted to give a subtle band of shadow behind the base of the glass.

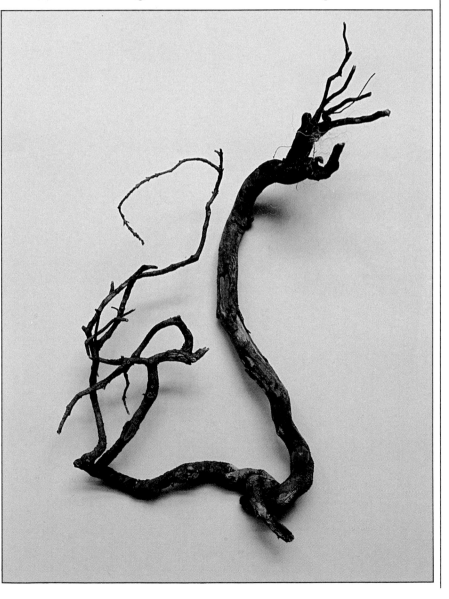

A gnarled branch, set against a surface of coated white paper, forms a background itself for a tiny ladybug. A diffused flash unit positioned just above and behind the camera produced soft shadows at each of the three corners of the subject.

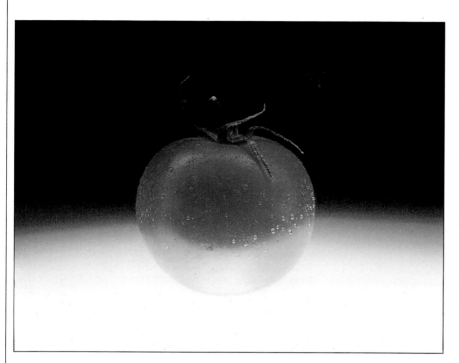

A tomato (left) seems to hover mysteriously in midair, its lower half dissolved by light. The photographer placed the tomato on a piece of thin white acrylic sheet, lighting just the front area of the sheet from below with a powerful tungsten light.

A raspberry impaled on a fork (bottom) makes a graphic still-life that exploits the reflective property of black acrylic sheet. The photographer used a photolamp with a large diffuser placed over it, as diagrammed below. The lamp itself was partly reflected in the background.

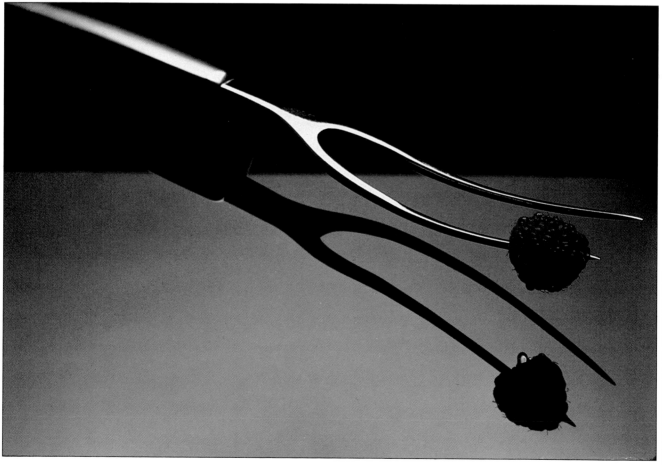

Textured and patterned backgrounds

The background in a studio photograph can make a major contribution to its impact. Patterns, textures and motifs on a background can complement the subject in front, form a contrast, as in the picture directly below, or add some extra dimension to the image by association.

The size of the subject largely determines the choice of background material: the background must be big enough to fill the frame, and its texture or pattern has to be clearly visible. For example, shot silk is distinctive in a close-up, but looks little different from other fabrics if hung behind a full-length portrait.

For portraiture and large sets, you need a back-ground that covers quite a wide area. Rolls of paper or fabric are inexpensive, and you can add texture to them by crumpling them up and lighting them obliquely or by spraying them with paint, as the photographer did for the picture opposite. With a bit of practice, it is even possible to spray quite realistic clouds onto blue paper.

For a smaller subject, such as a still-life, the background possibilities are virtually endless. Leather, wood, metal and fabric all have attractive textures, and many photographers store scraps of these materials for future use. Always keep your eyes open for unusual backgrounds that will echo some aspect of the subject, as in the photograph below.

Balls of wool (left) seem softer and smoother when juxtaposed with coarse-grained planks. The photographer lit the scene from the side to emphasize the contrast of textures.

Stacked chrome chairs form a rhythmic motif that is continued by the red venetian blinds behind. Reflective black acrylic sheet takes the theme still further, but twists and distorts it under the weight of the chairs.

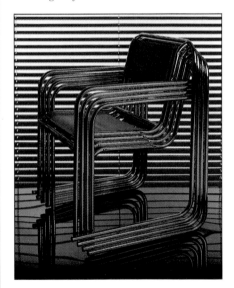

Riding high, a toddler (right) finds a firm foothold. To create a background that would complement the skin tones of the pair, the photographer sprayed a roll of chestnut-colored paper with dark brown paint. To achieve the softly mottled effect, he kept the background slightly out of focus.

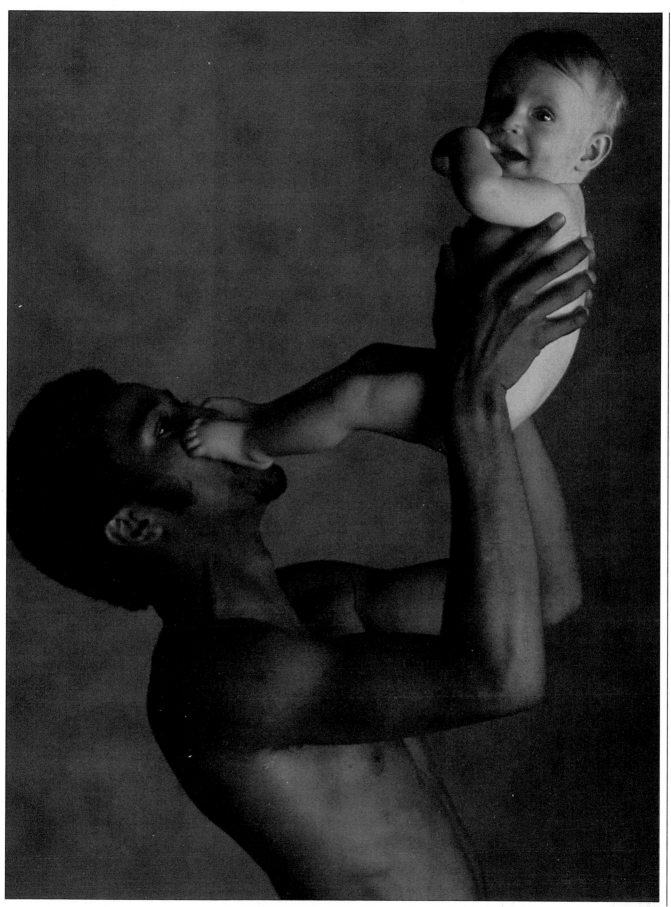

Simple sets

From using backgrounds as an integral part of your pictures, constructing three-dimensional surroundings for your subjects is a natural next step.

For a basic set, you will need at least one wall and a horizontal surface. You can easily make your own screens to serve as walls. Take a large sheet of plywood or fiberboard and nail braces cut from two-by-four wood to its bottom edge. Such screens are sturdy and will support shelving and wall fittings. For a corner set, you could use just one screen with the studio wall as a background. The screen can be covered with whatever is appropriate for the scene: wallpaper, a coating of plaster to simulate an outside wall, wood paneling or plastic laminate. For greater authenticity, you might add fittings such as a light switch or electrical socket, or authentic props like the old window shutter and draped lace used in the picture on the opposite page. The photographs below demonstrate a different approach. Here, the basic set is like a three-dimensional picture frame, which can be adapted with great versatility by changing the props and backgrounds.

One important point to remember when you are building a set is to leave room for the lighting arrangements, particularly if you wish to simulate light coming through a window, as in the picture opposite. Remember, as well, to make sure you mask the areas where surfaces are joined – for example, use a thin strip of wood to cover the gap between a screen and the floor.

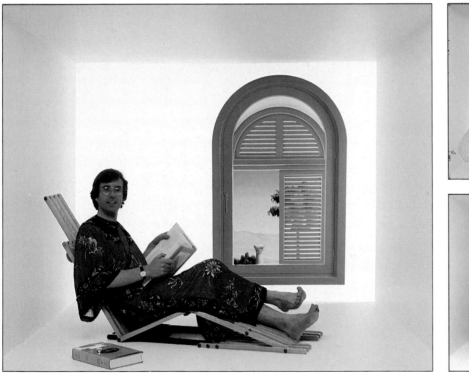

A "picture-frame" set
The diagram at right shows how the set was constructed for the three images on this page. Plywood was used for the walls and ceiling, blockboard for the floor; wooden braces supported the walls. To give the illusion of space and depth, the set was built to create a false perspective. The plywood pieces were cut to slope from a height of eight feet in the foreground to six feet at the back, with the ceiling set on a slope.

Three stylized scenes are each given a cool, uncluttered character by the plywood cube set diagrammed at left. For the lounging subject above at left, a painted window with an idyllic view was suspended against the white backdrop behind the set to create an appropriate mood. A change of props and background produced the bright, modern interior of the picture immediately above. With a different color scheme and a decorative edging of plants, the set became a fantasy scene (top). Scaffolding erected out of the camera's view supplied invisible support to the hammock.

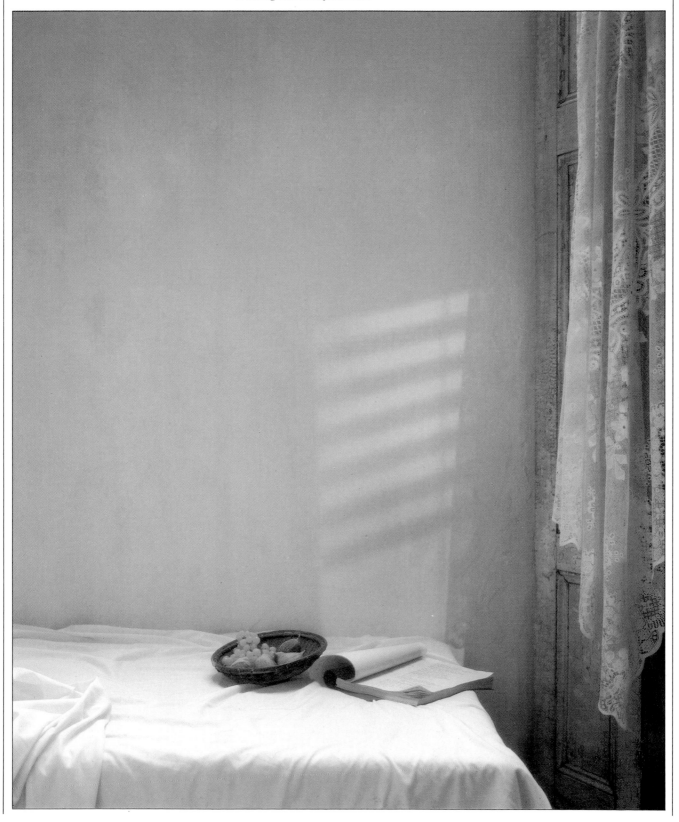

A pattern of light on a wall shows
how one detail can bring a simple set to
life. Two wall screens, a shutter, a length
of lace and a photolamp aimed through
a slatted frame were the basic elements
creating this tranquil scene.

Elaborate sets

Sometimes you may want to create a complete environment for a subject, suggesting a real-life location. At first, the prospect of reproducing a period drawing room or a saloon in your studio may seem impossibly ambitious. But by carefully considering scale and viewpoint, you can create sets such as the ones shown here relatively easily with rented or borrowed props.

The most lavish looking scenes can be based on a couple of screens, a suitable floor covering and occasionally a small area of ceiling. Professional photographers who specialize in room sets usually plan the view very carefully before they order materials. By limiting the set to the edges of your selected view, you save time, cost, space and work.

Make a scale drawing of the set and the angle of view you plan to use. Then draw the main lines of the plan in chalk on the floor before you begin to assemble the screens and props.

Your viewpoint, the way you position your props, and the kind of lighting you choose will all determine how convincing a scene is. In the picture below, lines converging from the foreground draw the eye in toward a wealth of background detail. In the set at the bottom of the opposite page, the lighting, which appears to be natural, focuses attention on the far corner to give an impression of spaciousness. The scene at top right required no elaborate set construction, just a clever use of background props.

An arrangement of period pieces re-creates the charm of a traditional parlor. The soft, even lighting reveals textures, colors and shapes, while the off-balance viewpoint enhances the informal mood of the picture.

A pool hall provides the setting for models in unisex fashions. A shallow set with authentic props in the background was lit with a combination of tungsten and daylight, then photographed on daylight-balanced film to suggest the characteristic mood of a large and dimly lit room.

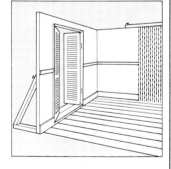

Louvered doors seem to lead out to a French café's courtyard. The artful use of angles and a meticulous eye for detail gave the basic corner set, diagrammed above, an impressive realism. Key elements are the simulated daylight from the doors and the bead curtain hung from a frame set at an angle to the background screen. The use of props beyond the main set – the plants and the television behind the curtain – and the diagonal viewpoint help to establish space and depth.

Front and back projection

Instead of using a conventional background or set in your studio photography, you can sometimes achieve more impressive effects with a projected slide. By placing your subject in front of a projected background, you can re-create an exotic or faraway location, as in the picture opposite, or achieve bizarre images like the one below.

The most straightforward method of projecting a background is to use an ordinary slide projector to throw an image onto a white surface such as background paper, while you light the main subject separately. However, the projector must be angled obliquely to the screen so that the subject does not interrupt the beam and throw a shadow onto the background. Therefore, the technique only works if the projected image can tolerate distortion – for

example, if it is an abstract pattern, cloudy sky or stormy seascape.

You can overcome this limitation by renting a special front-projection unit and screen, which was used for the pictures here. The camera is mounted on top of the unit, as illustrated on page 25. The projector bounces the image toward the screen off a semireflective mirror angled at 45° in front of the camera lens. This device allows the camera lens and the projector lens to share the same axis, so that the shadow cast by the subject onto the screen is directly behind the subject and therefore not visible. The screen is made of tiny beads that reflect the projected light directly back toward the camera to create a very bright image. Compared to this brilliant reflected image, the light from the projector

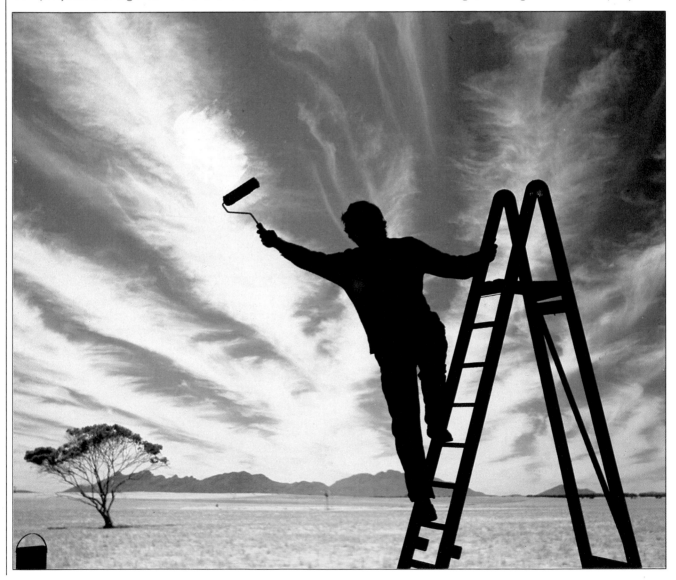

that falls on the main subject is very dim. When the subject is separately lit, the illusion of a single scene is complete.

As a cheaper alternative to front projection, you can try projecting a slide onto the *back* of a screen to create a background, with the subject – and the camera – placed in front as diagrammed at right. This technique, however, requires more studio space. The screen should be as smooth as possible. It should be thin enough to receive a sharp, bright image from behind, yet thick enough to prevent a flare spot from appearing where the center of the projector's beam falls. Special plastic screens are available, but a satisfactory alternative is to use a large sheet of thick tracing paper mounted on a wood frame.

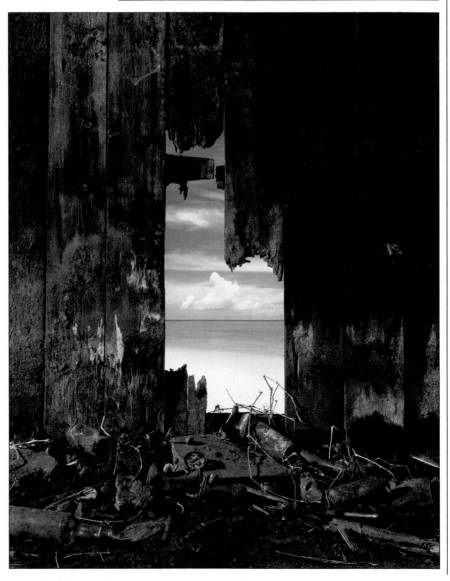

Back projection
To create your own studio background by back-projecting a slide, use the setup diagrammed at right. Position the projector (1) behind the screen (2) and mount the camera on a tripod (3) in front. Make sure that no stray light reaches the rear of the screen. Place the subject as far in front of the background as possible. To prevent light on the subject from falling onto the screen, keep studio lights well to the side, shade them with a sheet of black cardboard (4) and attach a barndoor or snoot (5) to narrow the beam.

A gap in the wall of an abandoned wooden shack appears to reveal an idyllic seaside scene beyond. The photographer set up a mock interior with a jagged opening and used a front-projection unit to project a slide showing a beach scene onto a highly reflective screen beyond the opening. The studio lighting on the foreground supplanted the dim projected image that fell on the wooden planks.

A housepainter (left) on a ladder, silhouetted against a flat landscape, seems to apply color to the sky with his roller. A front-projection unit, used to create the background, ensured that the shadow thrown on the screen by the figure and props was out of view, directly behind them. No lighting was used other than that supplied by the projector.

Captive sets

Small land creatures and fish can be difficult to photograph in their normal habitats, not only because of their size but also because of their sudden, quick movements and their tendency to prefer dim light. Photographing them in special studio sets gives you more control. At the same time, it demands special care and sensitivity. Timid wild creatures are easily distressed, and it is best to choose subjects that can live happily in an aquarium or vivarium. Remember, too, that some species are protected by law and must not be removed from their natural environment.

A captive set should re-create as closely as possible the subject's habitat while confining it temporarily in a setting that shows it from as many angles as possible. A regular aquarium can easily be adapted for a set, as demonstrated in the diagram below, right. For small mammals or reptiles, you can also construct a temporary enclosure with glass panels and a wooden frame. A dark background will help make the subject stand out. Alternatively, blue or green cardboard or a natural material, such as the leaf in the picture at right, are good choices. Flash is usually the best type of lighting: it will freeze rapid movements and emphasize highlights – for example, in the eyes. Use two or more flash heads to reveal rounded form and detail. If you are photographing through glass, be sure to angle the flash to avoid reflections, and mask the camera with cardboard as shown in the diagram.

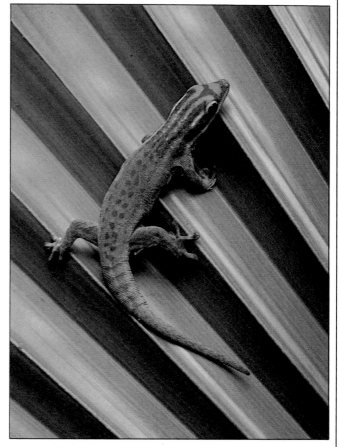

A lizard on a palm leaf (above) is lit by a broad, diffused light placed close to the camera. The choice of this natural background with a strong pattern made an elaborate set unnecessary. The photographer used a 55mm macro lens.

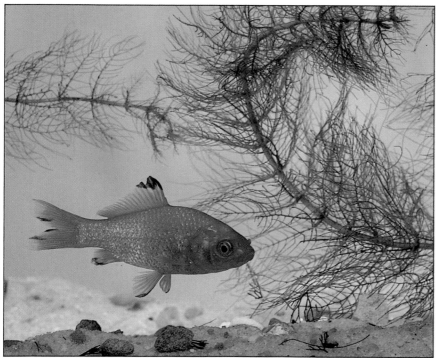

A goldfish (left) swims near feathery water weed. A glass partition (diagram, above) inserted inside the aquarium trapped the fish in a narrow channel. Flash heads on both sides of the tank provided good modeling light and green cardboard supplied a natural-looking background. To reduce reflections, a piece of black cardboard, with a hole for the lens, was placed in front of the camera.

A dormouse on a honeysuckle branch fixes its bright gaze on the camera. The photographer placed the animal in a glass and wood enclosure and photographed it with flash, using extension tubes. The black background reveals fine detail.

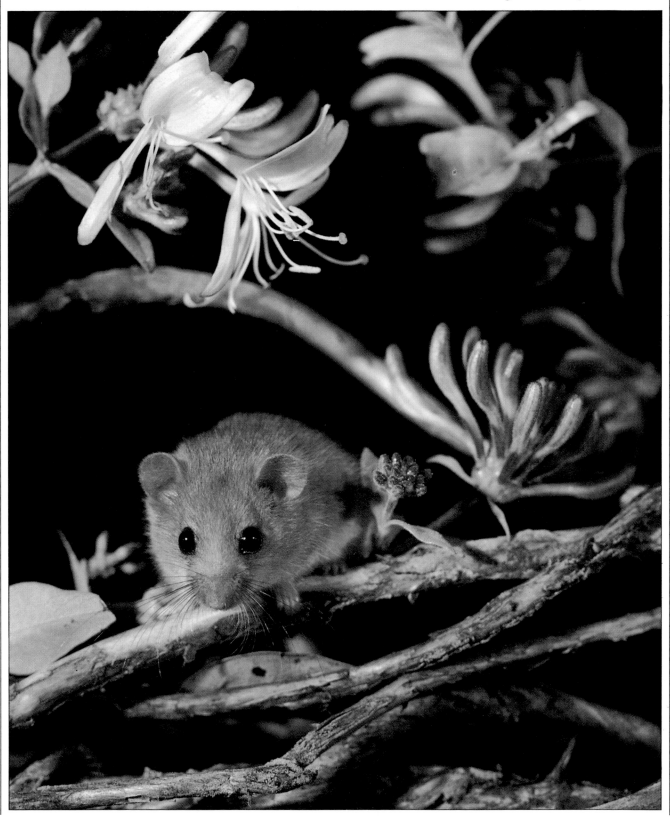

PEOPLE
IN THE STUDIO

While candid pictures catch people as they go about their daily lives, a studio session with a human subject is highly planned from start to finish. To achieve a particular effect you have in mind, you must carefully work out the setting, lighting, pose and viewpoint, always paying close attention to the unique qualities of each subject.

There are many different approaches to photographing people in the studio. In portraiture, your main aim is usually to bring out the sitter's personality. Even an infant has expressions and gestures that hint at a growing character. In fashion photographs, the emphasis is strongly on appearance: the model is only a starting point for a whole range of styles and moods. With nude studies, the approach is even more anonymous and objective: shapes, forms, colors and textures, rather than the individual person, are the important elements. Whichever approach you choose, thorough preparation for a session will allow you to concentrate fully on relaxing and directing the subject so that you capture just the effect you want.

A little girl's dignity and poise are emphasized in a superbly composed portrait. Despite the formality of the pose, the props and lighting produce a very natural effect. A powerful photolamp on one side, with no fill-in light for the shadow areas, provided strongly directional lighting that was ideal for this child's special presence.

Tightly framed portraits

Portraits that concentrate on the sitter's head have great visual strength and unity because they give full prominence to the most expressive elements of the human figure – the face and, in particular, the eyes. For this reason, a head-and-shoulders or half-length view are the classic ways to frame a portrait. Because this framing leaves little space for elaborate props or settings, the way in which you arrange the composition is all-important.

Even in a spare, simple composition that closes in on the subject to fill the whole picture area, there are many ways to vary the framing to produce original, perceptive portraits. The classic full-face close-up below at left reveals the symmetry of the features and the soft, flawless skin. In the picture at

the bottom of the opposite page, tight framing works in a different way to pull the viewer into the center of the image.

You can make use of unorthodox positioning to give dramatic impact to a portrait, as in the example at the top of the opposite page, where most of the weight of the composition is on one side. Here, the angle of the hand and the brilliant beam add dynamic movement and interest to an empty background area. However, you need not rely on the edges of the picture to provide a frame for the subject. In the unusual composition directly below, a rectangle of light creates a glowing half-length portrait with a dark background to which bars of light add tonal contrast and visual interest.

Healthy good looks (right) are enhanced by a rustic setting. The screen of rough stained wood, suggesting an old barn, was placed in front of a roll of seamless white paper, separately lit to simulate bright daylight. The subject was lit from the front with a spotlight. Hinged flaps mounted on the front of the spotlight created the rectangular frame.

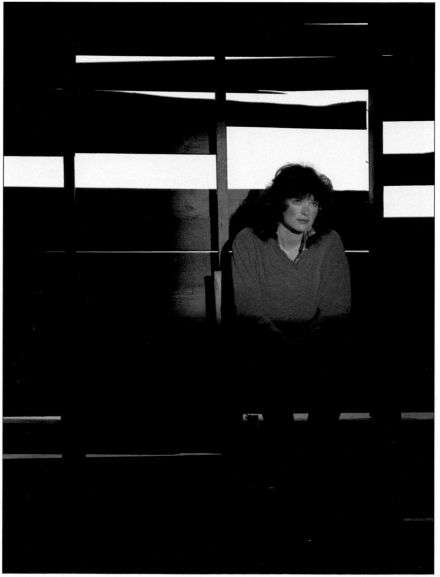

Warm, translucent color (above) suffuses a classic close-up portrait. The model's makeup and dress, as well as the framing, the background color and lighting, were all chosen to focus interest on her face and especially on her unusual gray eyes. Diffused front lighting and a soft-focus filter produced the delicate pastel hues.

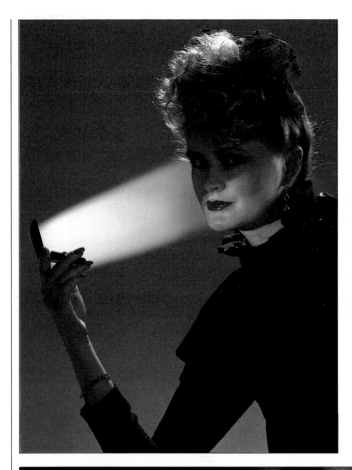

A beam of light, apparently emanating from a compact mirror, helps to balance the off-center framing in a theatrical portrait *(left).* To create the effect, the photographer set up a projector to throw a rectangle of light onto the dark background *(diagram, below).* A spotlight was directed onto the subject's face. Two more lights above and behind the head cast a halo around her hair and revealed fine detail on the side of her face and neck.

Lowered eyes and a raised hand give a brooding tension to the portrait below. The horizontal format and bold cropping concentrate attention on the subject's essential features, as does the understated sidelighting off a 12-inch reflector. The photographer used the highlight on the shiny pendant to draw the eye into the frame.

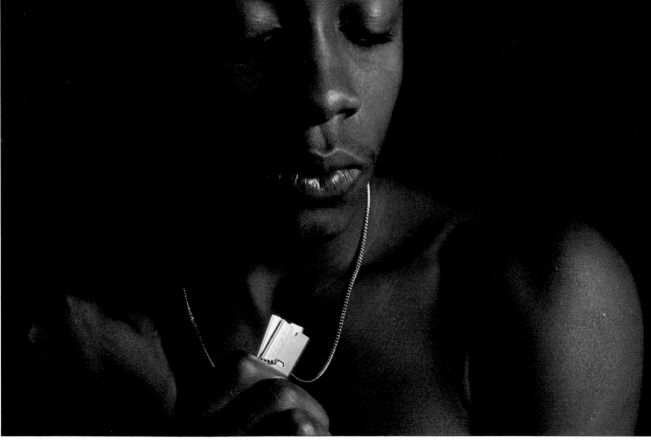

Full-length portraits

Photographing a whole figure requires a different approach from that used in the tightly framed head-and-shoulders portrait. To begin with, you need more space, both to allow for more complicated lighting arrangements and to fit the subject and surroundings into the frame without cramping them.

Setting and pose also need careful consideration. Generally, a seated pose is best: the subject will appear more relaxed and natural with some support, and the hands and head – the most expressive parts of the body – will be prominent. The two large pictures below illustrate the point. However,

a standing figure in a stylized pose can make a dramatic image, as in the portrait on the opposite page; here, simple props and a plain background combine with contrasty lighting to achieve an unusual and evocative effect.

Carefully selected props can strengthen a composition and help reveal personality, especially when they are linked by a common theme. However, avoid clutter; make sure each element enhances rather than distracts from the main subject, as in the portrait below at left, in which the overlapping shapes draw the eye into the frame.

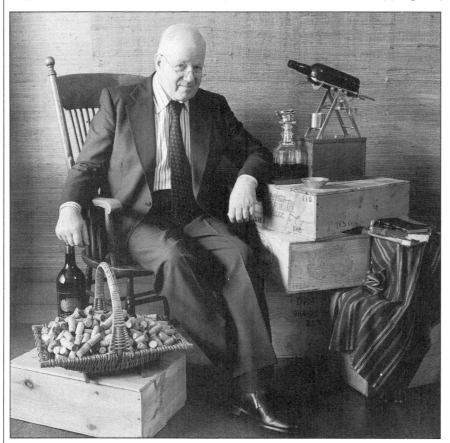

Wine crates provide apt and simple props for a portrait of a wine merchant (above). The basket of corks and the bottle on the stand help pull the eye toward the figure, emphasizing the relaxed but alert tilt of the head.

An artist (right) is surrounded by her work and materials. The picture derives its impact from artful framing, which focuses attention on the pattern of irregular shapes, echoed in the sitter's pose, and on her dreamy expression.

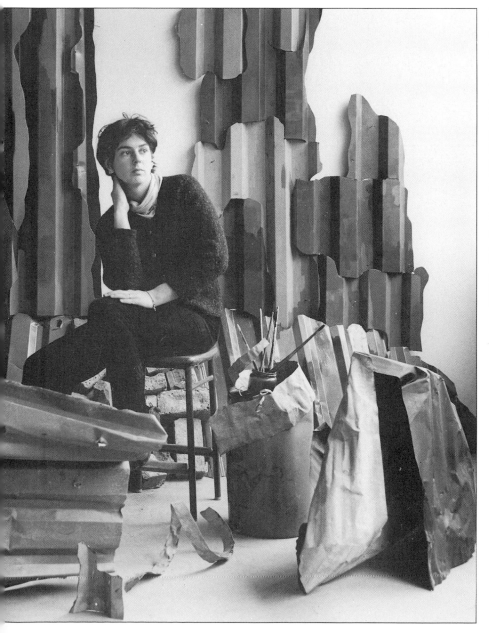

Picturesque props and subtle
tones heighten a nostalgic mood (above).
Strong directional lighting from one side
created dramatic highlights and shadows
that balance the elements in each half of
the frame. The woman's pose provides
curving lines that lead the eye around
the figure to the baskets and back again.

Groups and pairs

Photographing more than one person in the studio makes great demands upon both your compositional skill and your ability to direct your subjects. Usually, informal poses are preferable, unless you want to emphasize a hierarchical relationship. Imaginative use of props, as in the photograph on the opposite page, above, can also help lend impact and sometimes humor to a composition.

With large groups, a plain background is often best. However, if you place the group centrally in the viewfinder, you incur a risk of dullness at the edges of the frame; to avoid this, try cropping in close, as in the picture on this page. An alternative approach is to choose a background that suits the subjects' collective character, occupation or interest – after all, this is usually the reason they are being photographed together – as in the lively image on the opposite page, below.

Make sure that each face is clearly lit and that the members of the group do not cast shadows on each other. To be confident of getting an interesting expression on every face, you should shoot at least one roll of film. Often the best pictures are candid ones taken when the group is off guard.

British pop performers pose in a tight but informal group. The varied expressions and postures, the flamelike glow in the top left corner (from a spotlight with a red filter over it) and the magenta splash of a dress all add interest to the composition.

Lens to lens, *two photographers peer into the viewfinders of their unwieldy large-format cameras, their heads buried in black, light-tight hoods. A white paper backdrop and well-diffused, shadowless lighting concentrated attention on the bright colors and intricate shapes of the subjects.*

Leaping ladies *(below) form a slope of color in front of a wall of jazzy stripes and polka dots. The photographer played a pop music tape and encouraged these members of a pop group to dance uninhibitedly. Electronic flash froze their movement.*

Small children

Small children are exceptionally attractive subjects for portraits. Their freshness, their exuberance, their unaffected pleasure in simple things and above all their expressions, which can mirror every mood without a hint of reserve, offer the photographer tremendous opportunities for sparkling images. At the same time, these very qualities can make young children difficult to photograph well. They have a short attention span, and cannot be kept still for long before they become tired and fidgety. And their marvelous expressions are usually fleeting, so you must capture the moment as it happens.

One important requirement for child photography is enough space to allow the photographer to keep a discreet distance and prevent the subject from feeling inhibited. You also need a simple setting. Strong colors or patterns in the background or elaborate props can easily overwhelm the subject. A plain white background – for example, a roll of seamless paper, as used in the portrait on the opposite page, above – will show off delicate features and textures. Alternatively, a dark backdrop, as in the picture below, will give good tonal contrast and definition of shapes.

Lighting also should be kept simple. The heat and glare of photolamps are uncomfortable for young subjects. Instead, make use of diffused daylight through a window, with reflectors to spread the light around the subject. Or use bounced or diffused flash – for example, with umbrella reflectors. Flash also allows you to set a small aperture, making focusing easier. Have your lighting arrangement set up before the session begins, and take exposure readings in all directions to ensure that the illumination is broad and even.

Finally, try to make the session fun for your subject. An absorbing toy or game will relax the child so that he or she forgets the camera; it can also add visual interest, as does the dollhouse in the enchanting candid portrait opposite, below.

A trio of toddlers is linked by an arrangement of simple props, which provide a good composition with strong shapes. The dark background and soft light from two flash units outfitted with umbrella reflectors show the skin tones and textures to their best advantage.

A baby (right) plays with a new toy, unaware of the camera. The child's absorbed expression and his relaxed pose are brought out by broad, almost shadowless lighting from a diffused flash unit. By using a 135mm lens, the photographer was able to avoid distracting the child.

A little girl (below) is lost in private daydreams. A spotlight behind her head cast brilliant highlights on her hair. Reflective surfaces on the dollhouse threw light up into her eyes, and a gold reflector placed just below the camera helped fill in shadow areas at the front.

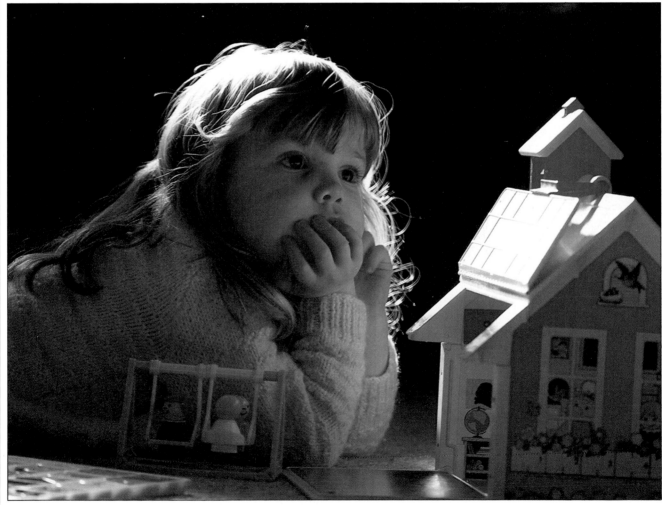

Fashion

Most portraits try to capture the sitter's character. However, a contrasting approach is to idealize the subject, creating style rather than revealing personality. This is the domain of fashion photographers. By borrowing their skills and applying them to friends or other willing subjects, you can achieve stylish images that conjure up the seductive world of high fashion.

To emphasize the beauty of skin tones or other soft textures such as that of the fur coat in the picture at the bottom of the opposite page, diffused, low-contrast lighting is the best choice. You can often disguise skin blemishes with skillful makeup or by overexposing by half to one stop. A high, frontal, diffused main light with a reflector placed close beneath the face is a classic setup for head-and-shoulders photographs. But low-contrast lighting sometimes causes an effect of blandness; you can

avoid this by using imaginative compositions, by strengthening the makeup, or by adding eye-catching accessories such as the white-framed sunglasses in the picture below.

When showing off beautiful clothes, choose backgrounds and props that create an appropriate atmosphere. An element of drama in the lighting, background and pose often gives a memorable result, as in the picture opposite at far right. For an arresting image that involves the viewer, try getting the model to look straight at the camera with an expression of challenge or defiance.

For a livelier effect, ask your model to move freely while you photograph a sequence of frames, as explained opposite. Music can help promote a relaxed atmosphere and a natural flow of movement. This method is particularly appropriate for displaying fabrics that can be swirled or tossed.

A softly lit portrait gains impact from its simple composition. By tying back the model's hair and shading her eyes with sunglasses, the photographer focused attention on her full lips and broad, smooth brow.

A **Japanese screen** and pale,
Oriental-style makeup give a touch of
exoticism to this double fashion photo. A
spotlight behind the screen and another in
front, isolating the seated model, provided
the dramatic lighting.

Directing a model

To inject vitality into your
fashion photography, get your
model to move around while
you take a succession of
pictures, either freezing
movement with flash or
blurring it in tungsten
lighting. Encourage the
subject to relax and get
her to move her body and
limbs to make interesting
compositions. This approach
can work well with clothes
that can be worn in different
ways, as in the two pictures
immediately at right.

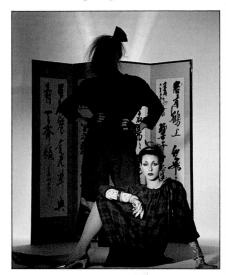

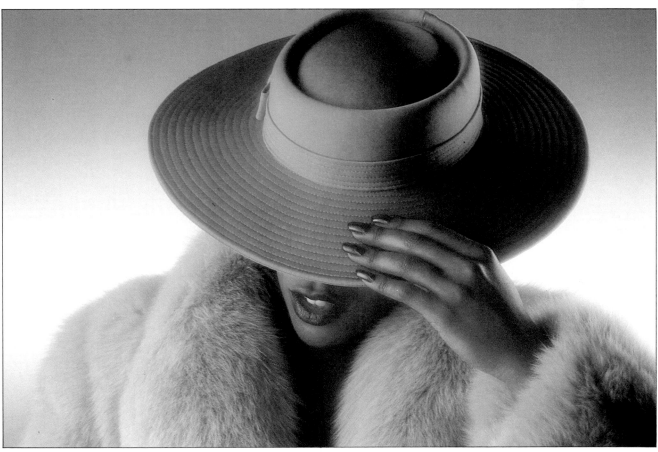

*A **mink coat** and an elegant turquoise
hat frame lovely, parted lips but leave the
rest of the face a tantalizing mystery. A
pair of diffused flash units, one on each
side of the camera, provided soft, sensuous
lighting appropriate to the subject.*

The nude

Photographing the nude in the studio has more in common with still-life work than with portraiture. The conventions that govern portrait lighting become less important when the subject is nude, and the photographer is freer to use the face and body as elements in an abstract composition.

By carefully positioning the studio lamps, you can reveal as much, or as little, as you choose of a model's body. Backlighting, or lighting just the background rather than the figure, allows you to create a mysterious silhouette, as below at right. By progressively introducing lights or reflectors, you can gradually restore form and roundness to the body.

Hard lighting rarely suits the nude; it emphasizes even a slight lack of muscle tone. However, if you are photographing someone in fine physical shape, such as the figure on the opposite page, using an undiffused light source to form brilliant highlights on the skin can create dramatic effects.

Diffuse lighting is flattering to the rounded curves of the female form, producing gentle shadows when the light source is on one side. By diffusing a large, front light source, you can produce near-shadowless lighting that works well when you want to focus on shape rather than contours, as in the stylized image below at left.

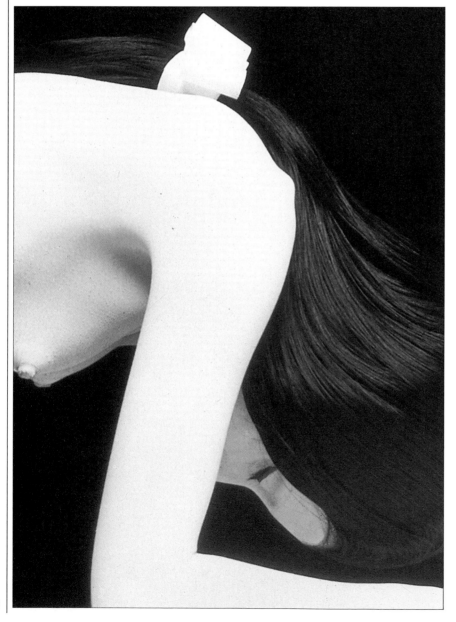

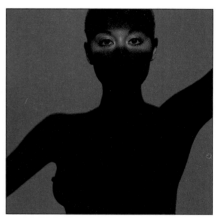

Shining eyes (above) gaze intently at the viewer in this unusual nude study. To create the tightly framed rectangle of light on the model's face, the photographer masked the front of a tungsten spotlight with barndoors.

White makeup and a highly stylized pose evoke the traditions of mime and theater. Soft lighting and cardboard reflectors prevented harsh shadows from breaking up the blanched perfection of the model's body.

A black figure (opposite) seems to have turned to gold in hard toplighting that strikes the tensed musculature of his shoulders and buttocks. Body oil helped to create the glossy highlights that emphasize the statuesque effect.

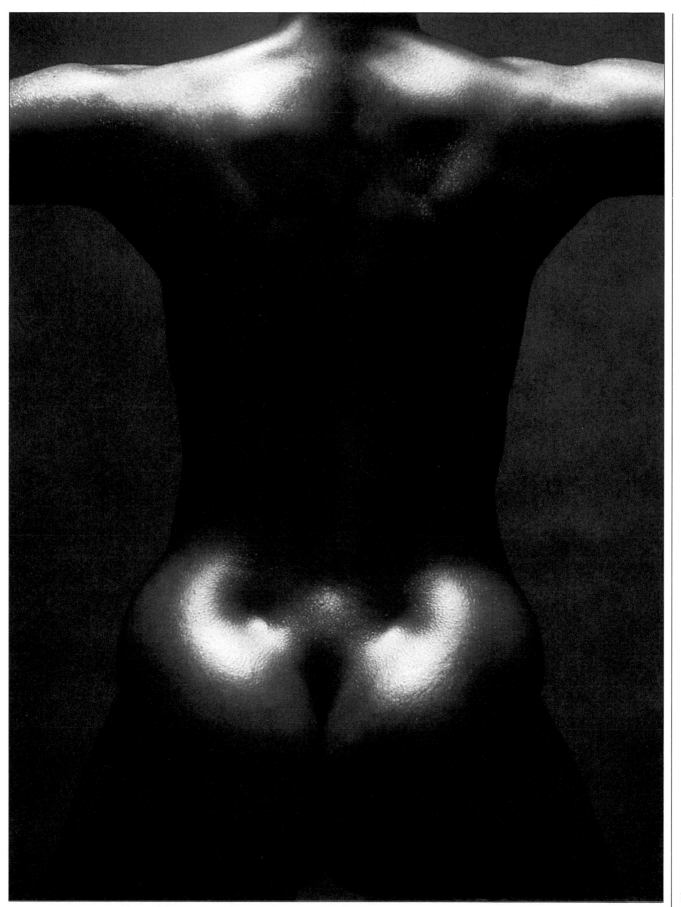

STILL-LIFE IN THE STUDIO

A traditional subject for artists, the still-life has become a classic photographic theme – and one that especially suits the controlled conditions of the studio. Often, the term "still-life" is associated with arid and static images. Yet this field offers tremendous potential for exciting and innovative pictures. Subjects of all types and sizes – from a miniature study of jewelry, to elaborate arrangements of food, to a complete room set – are possible still-lifes. And by using different lenses and lighting arrangements, or by modifying a setting, you can reveal a range of different characteristics in a single subject.

The great advantage of still-life photography is that you have total control over every aspect of the composition; you can even create your own version of real-life objects, as in the picture at left. This section explains the techniques involved in photographing a variety of still-life subjects, from simple composition and lighting to the more exacting requirements of special subjects like jewelry or food.

Paper cabbages provide a whimsical still-life that gently teases the viewer's visual concepts. Diffused light from a photolamp above and on one side of the set ensured that subtle tonal and textural contrasts in the subjects and background were not cloaked in deep shadow.

Composition

Still-life is the one area of photography where composition is wholly in your hands. The exact position of every element in the image is your choice. Yet this total freedom can be inhibiting; you may not know where to start. Following some basic compositional guidelines need not limit your creativity and will help you build pleasing, unified images.

A still-life should be self-contained, whether it is a detailed study such as the flower on the opposite page, above, or an elaborately constructed scene such as the one below. Each ingredient should make a real contribution to the overall effect, with subsidiary elements supporting the main subject. This can be done in many ways: for example, by using lines to frame and lead into the subject, by juxtaposing complementary or contrasting tones and shapes, or by echoing a pattern on a smaller or larger scale. The precisely balanced picture opposite, below, makes use of all these techniques.

A good way to learn about composition is to start with just two or three simple objects and practice moving them around to find the strongest arrangement. With the camera on a tripod, you can keep the view constant while you adjust the set and lighting. For more complex still-life arrangements, it is especially important to keep a strong focus of interest. Once the background and main subject are in place, add secondary elements one at a time, checking through the viewfinder to gauge the effect of each addition.

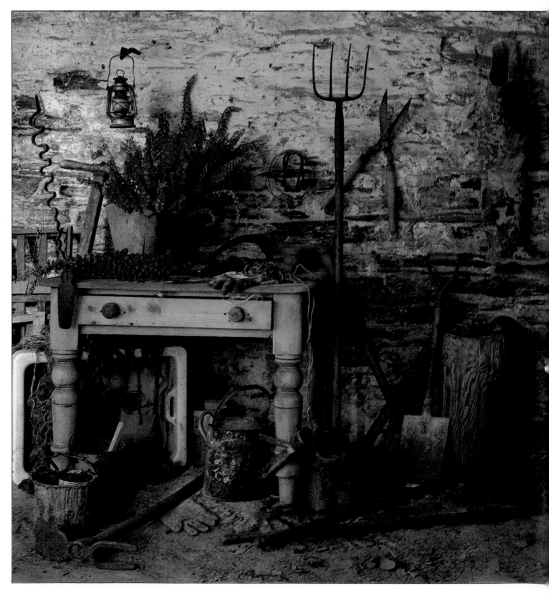

A country life theme links an array of objects. The apparently haphazard arrangement was assembled in an elaborate studio set to produce a harmonious composition of natural tones and textures. Strong light from one side concentrates the eye on the main subject: the freshly cut foxgloves.

Lily blooms (right) stand out in strong relief against a black background. Centering the subject brought out its symmetrical pattern, while lighting on each side and slightly behind revealed its subtle textures and hues.

Speckled eggs (below) provide the main interest in an intriguing still-life. Each element contributes to the unity of the composition, in which the echoing colors, lines and textures lead the eye easily around the image.

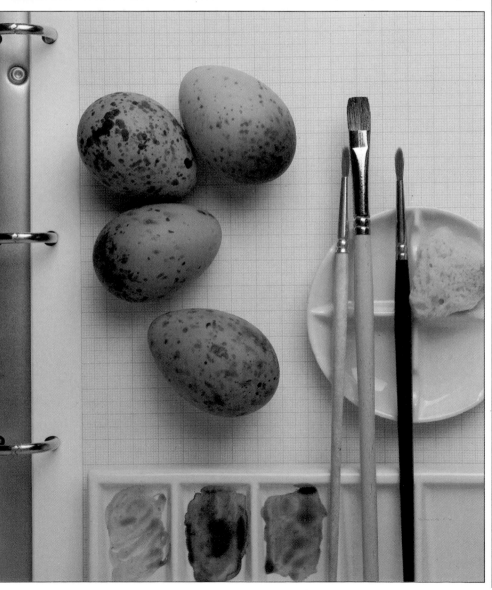

Color

The most effective still-life photographs are those with a clearly dominant element in the composition, and one excellent means of providing such a focus of interest is by skillful use of color. The pictures on these pages exemplify some of the tremendously varied effects you can create by experimenting with color in the studio.

Colors used singly or in relationship with one another can establish a particular mood. For example, in the image at right, bright colors arranged in tonal groups to form patterns of irregular vertical lines suggest dynamic movement. Grouped subjects such as this, identical except for their colors, can be arranged in different ways to create restful, harmonious designs or bold, off-balance ones.

You do not have to fill the frame with brilliant colors to obtain eye-catching results. A restrained use of color can point up an unusual combination of objects, as in the composition below, where the boldly centered splash of red and green provides contrasts in scale and texture as well as color. Monochrome color, as in the image on the opposite page, can simplify a picture and unify its elements.

Colored pencils create a strong abstract pattern against a solid black background. The pencils were arranged to provide subtle color modulations in an arrangement of three distinct contour lines.

A pride of plaster lions (below) is juxtaposed with nasturtiums. Diffused lighting with plenty of reflectors kept the background clear of dark shadows, which would have detracted from the pure, saturated color accents.

A monochrome still-life has a
sculpted appearance. The photographer
coated the elements with liquid clay and
used a hairdryer to create the cracks.
The plate was supported on a hidden wire
to produce the gravity-defying illusion.

Transparent objects

A still-life that includes a transparent object such as a wineglass or glass bowl needs judicious lighting. To darken the edges of the object in order to reveal shape, some backlighting is required. There are various ways to achieve this. One is to place the item on a diffusing surface such as acrylic sheet and light it from below, as in the picture opposite. Or you can use a curved sheet of light-colored plastic laminate as a background and set up an overhead unit to bounce light from the background onto the subject. With this method you can create a background that shades off from dark to light, depending on the lighting angle. To show detail on the front of the subject, use supplementary frontal lights or reflectors.

If you want to strengthen the edges further, you can exploit the reflective properties of glassware. An effective technique is to use a light-colored background and set up black cardboard screens on either side of the object, as diagrammed below. Conversely, use white cardboard screens at the side and a black background.

Often, a curved glass surface will unavoidably reflect the light source. This reflected highlight will normally be quite acceptable if the light is covered by a rectangular diffuser; indeed, it can enliven a composition and suggest shape. But you may wish to try using such reflections for a more adventurous effect, as in the picture below at right.

A glass bowl packed with fruit makes a colorful still-life. The reflected "window" is in fact a reflection of the diffused photolamp over which the photographer stuck a cross of black tape.

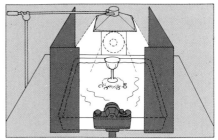

A goblet (left) on an island of moss and pebbles casts a reflection in rippled, milky water. Top and back lighting revealed the transparency of the goblet, and was soft enough to hold detail in the delicate paintwork on the bowl. Dry ice produced the "mist". To give definition to the stem and bowl, the photographer placed pieces of black cardboard at either side (diagram, above).

Green vegetables and lemons fill
hollow blocks molded from ice. Holes cut
in a sheet of green gel placed over
clear plastic facilitated the dramatic
bottomlighting effect, which was
supplemented by a weak overhead light.

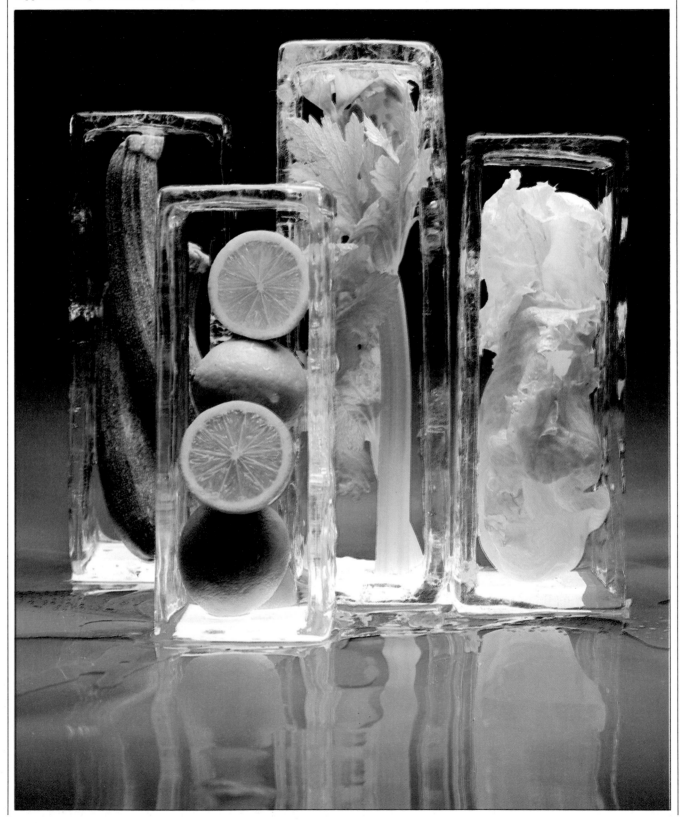

Offbeat still-lifes

The complete creative freedom a photographer has in fashioning a still-life composition can produce startling and original images that are far removed from orthodox treatments of traditional themes like flowers or fruit. On a simple level, the inclusion of one small, curious detail can prompt a fresh appraisal of classic themes. The picture below at left is an example of this strategy.

Another approach is to select prosaic subjects and give them new expression with innovative lighting arrangements or, as in the center picture below, with an unexpected angle. An extremely high or low viewpoint, or a wide-angle lens, can also be used to give fresh meaning to familiar objects; or, if the still-life has depth, a wide-angle or telephoto lens can distort size relationships in interesting ways.

Constructing your own models and sets allows you to create highly individual still-lifes, in which the color, shape, pattern and position of each element are entirely under your control. For example, in the picture on the opposite page below, disparate objects are linked by their marble patterning.

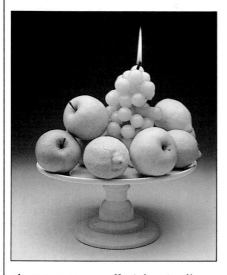

A wax grape candle (above) *enlivens a classic still-life of fruit in a bowl. The photographer used a dark background to emphasize the flame and masked off part of the diffused light source with black cardboard, so only the foreground area of the set was illuminated.*

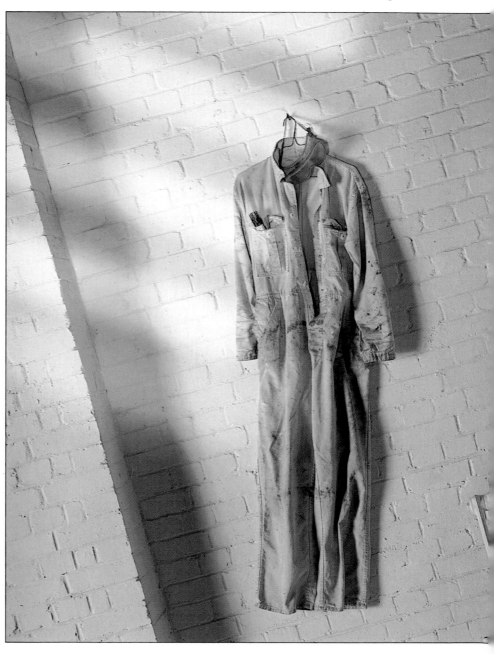

Overalls and a light bulb (right) *hang at an impossible angle in this bewildering view. Stiff wire was used to hold the hanging objects in place while the camera was tilted to take the photograph. Painted color accents add compositional interest.*

A painted statue on a checkerboard of linoleum provided the ingenious set for a fabric advertisement. The mallet, chisels and marble chips casually strewn on the floor playfully suggest a newly finished sculpture ready to be unveiled.

Small objects

Photographing small objects in close-up requires technical precision and is therefore best done in studio conditions. You can use either a normal lens with one or more extension tubes, or a macro lens. Only a few square feet of space are needed.

Small objects demand carefully scaled lighting. A large light that suits a still-life of fruit or tableware may be too diffuse to show up important details when used with a smaller subject, such as the shell below. Sometimes a portable flash is quite sufficient. Alternatively, to avoid shadows, you can use a ring flash unit, as the photographer did for the picture on the opposite page at far right. However, shadows can give useful definition to finely textured surfaces if you use a raking light from one side, as in the still-life with keys (center) or the coin below at left.

The restricted distance between the lens and subject makes soft, diffused, frontal lighting difficult to achieve in close-up work; sometimes it is impossible to avoid the shadow of the lens falling on the field of view. An alternative approach is to enclose the subject in a tent of thin white fabric with a hole at the top for the lens. You can then provide soft directional light from a unit placed to one side of the tent; or, for even lighting, you can place an additional unit on the opposite side.

A seashell proffers its unique beauty. A small studio flash with a sheet of translucent white plastic over it gave shape and modeling to the shell, with soft shadows defining its whorled form.

A French coin glitters attractively, its embossed details picked out by a low-angled light from one side, which creates a pattern of shadows and reflections. The photographer aimed his camera downward onto the subject. To prevent light from falling on the background he raised the coin on a small block of wood.

Keys on a green felt background show a remarkable range of textures, revealed by strongly directional lighting that casts diagonal shadows. To make the lighting more even, the dullest key was placed closest to the light source.

A stalk of meadow barley, evenly lit by a ring flash, makes a crisp image. The photographer chose a black velvet backdrop to reveal the barley's fine whiskers, which form delicate highlights radiating from the central stem.

Jewelry

To show off gemstones or precious metals to best advantage, the traditional approach is to use a background of crumpled velvet. However, this method ignores the marvelous opportunities for more imaginative backgrounds and props. For example, all three photographs here make use of bold contrasts of texture or color. They also indicate how the pieces will look when worn, though in a creative rather than literal way. One good reason for showing jewelry in a real or simulated human context is to give a clear idea of its scale.

To add precisely positioned highlights to a photograph of jewelry, use foil reflectors or small mirrors. The reflectiveness of polished metal surfaces can sometimes be a problem. One way to remove unwanted reflections is with a dulling spray, to give the surface a temporary mat coating. But this usually detracts from an object's appearance. An alternative is to place the piece in a light tent – an enclosure made of diffusing material with a hole cut out for the lens; if a reflection of the camera lens is visible, use a dulling spray just on that area of the surface.

A headband of silvery ivy leaves and pearls contrasts with the white face and carmine lips of a plaster head. To avoid a color cast, the photographer wore white.

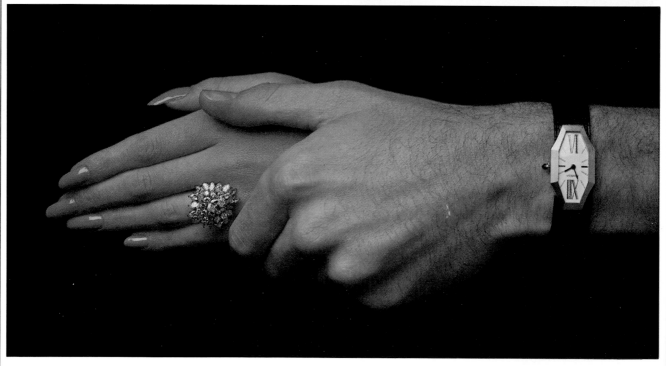

Clasped hands make an elegant setting for a watch and ring. To intensify the brilliance of the diamonds and the shine of the watch, the photographer darkened the models' hands with makeup and lit the subject brightly.

A crown of flame was
created for this image by
making a double exposure
– one of the singed cardboard
cutout, one of a burning piece
of similarly shaped black
cardboard against a black
background.

Flowers and plants

Under studio conditions, you can capture the fine detail of flowers and plants much more easily than when the subject is outdoors, where, apart from the fact that the slightest breeze will cause movement, the light may be unsuitable and the surroundings distracting or awkward to work in.

As the pictures on these pages demonstrate, flowers and plants offer considerable scope for creative composition. A close-up view, such as the one at right, can be a precise nature study, or can exploit the inherently strong patterns of leaves and petals for a bold abstract image. Props can be used to produce a stylized effect, as in the picture opposite, or to suggest a natural context for a flower arrangement, as below. Since plants look most attractive when fresh, you can spray them with water just before photographing them. Hot photolamps may cause wilting: instead, use diffused flash.

Orange blossoms (below) are enhanced by the harmonious neutral tones and restful lines of the setting. Soft three-quarter lighting gave good detail to the subject. The hand mirror reflected light into the shadow areas, giving depth to the image.

A dew-fresh peony is revealed in close-up. The photographer took an exposure reading from the white part of the petals, increased by half a stop, then bracketed exposures so the flower would not appear in dull gray tones or burned-out highlights.

A model house provides
a visual pun for houseplants.
The plants were lit from
above by broadly diffused
flash and set against a black
backdrop for clean modeling.

Food/1

Conveying the essence of food in a photograph is a special challenge. Just as composition and lighting can lend depth and form to an image, so certain techniques can convincingly suggest the distinctive flavors and odors of foods.

Raw or cold foods, such as the ones pictured here, are easier to photograph than hot cooked foods, not only because preparation is simpler but also because the shapes, colors and textures are stronger and more readily recognizable. Try to make use of these qualities. In the lobster picture below, center, re-arranging the meat inside the shell vividly conveyed the flavor of fresh seafood, an impression augmented by the wet seaweed and the ice. And on the opposite page, below, jewel-bright fruits and berries heighten the appeal of homemade preserves.

Atmosphere is crucial to the success of food photography. Usually, strident colors, cold lighting or clinically modern sets are unsympathetic, sug-gesting prepackaged or frozen food. Most people

Crisp green salads, avocados and capers accompany a dish of prawns (left). The color theme, echoed in the tablecloth, and the overlapping shapes help link the elements. The avocados were polished to impart an attractive gleam. Hard lighting from a small lamp above and to the left of the subject supplied good contrast and definite shadows that bring out the different textures.

associate good food with a bygone age or rural tradition. You can exploit these nostalgic associations with props and lighting arrangements. Below at right, the classic simplicity of the table setting bathed in sunlight, and the soft-focus effect of the preserves picture, both suggest a period mood. With raw, whole foods, it is especially important to choose perfect specimens. Rub lemon juice on cut fruits or vegetables to prevent discoloration, and spray them with water for sparkling freshness.

A teatime spread of hard-boiled eggs and creamy cheeses creates a serene mood. A slide projector fitted with a cardboard cutout "slide" threw patterned shadows as if from a venetian blind on the white cloth and the studio wall. Tungsten lights with daylight film produced an orange cast that simulated the warm color of late-afternoon sunlight.

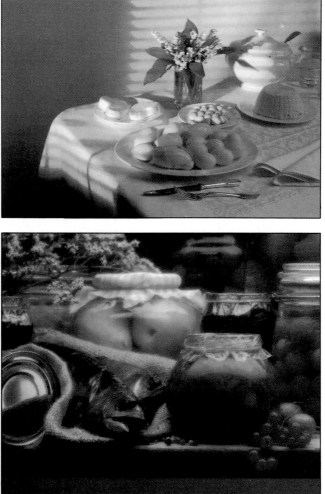

A lobster's rich colors and textures (above) are shown to their best advantage, thanks to meticulous preparation and careful positioning. The scalloped pewter dish and the dark wood surface suggested the sumptuous quality of the food, while the small dishes emphasized the shape of the claws. The lobster shell was painted with oil to give it extra shine, and ice was added at the last minute for freshness.

A shelf crammed with preserves suggests a well-stocked country larder. The photographer placed some items at the edges of the frame to convey a sense of plenty and used a soft-focus filter to enhance the mellow autumnal feeling. A large diffused light above the set gave fine modeling and soft highlights to the shiny surfaces. The smoked fish on the sacking provided a focus of interest.

Food/2

To make hot food look appetizing in a photograph, you need high-quality ingredients that are perfectly cooked. Enlisting the help of a friend with culinary skills will make things easier; you can then concentrate on the set, the lighting and the precise timing necessary to show the food at its best. A kitchen area adjacent to the studio is essential. There should be rapid access from the cooking unit to the set, but be careful that your equipment is not exposed to splashing liquids or spitting fat. A portable gas burner is useful, but check that you have adequate ventilation, and keep a fire extinguisher near by.

Once the dish is ready, you will have little time to work: congealing sauce and tired-looking vegetables are most unappealing. Set everything up in advance using dummies, and if possible make two identical versions of the real thing, one ready a few minutes ahead of the other so that you can make final adjustments to the composition. To convey the impression of heat, dark or warm-colored backgrounds, as used for the picture at right, are best. If you keep the room cold and use partial backlighting, you can show wisps of steam rising from the dish. A diffused light above and slightly behind the set will also reveal texture and emphasize shine on glossy surfaces, as in the mouthwatering picture below. Flambéed dishes, such as the one opposite, need careful exposure for spectacular results.

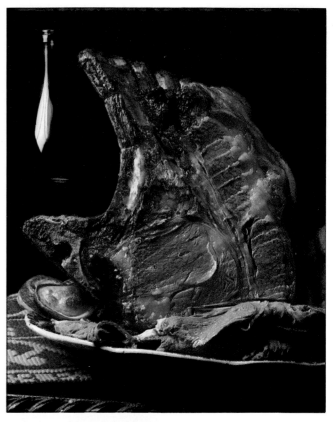

A standing rib roast
(above) is served with the traditional accompaniment of Yorkshire pudding. Lighting above and to one side of the meat reveals its rich colors and textures.

Fried eggs and bacon
(left) sizzle in a pan. The food was removed from the heat and photographed while the fat was still bubbling, with the egg shells placed next to the pan to emphasize the food's freshness.

Flaming crêpes suzette
(right) provide a dramatic focus for a display of hot dishes. A straightforward exposure with a studio flash unit would have washed out the flame. To overcome this problem, the photographer set the shutter on its B setting, triggered the flash, then gave an additional exposure of 30 seconds.

Glossary

Accessory shoe
A fitting on top of a camera that incorporates a live contact for firing a flashgun. It makes contact between the flashgun and the shutter circuit to provide flash synchronization. The term "hot shoe" is sometimes used as an alternative to accessory shoe.

Artificial light
Any light source used in photography other than that from natural sources (usually the sun). Generally the term refers to light specially set up by the photographer, such as flash or photolamps. Photographic emulsions have different sensitivity to daylight and artificial light, and films may be rated for either type.

Available light
The existing light (natural or artificial) in any situation, without the introduction of supplementary light (for example, flash) by the photographer. The term usually refers to low light levels, for example indoors or at dusk.

Backlighting
A form of lighting where the principal light source shines toward the camera, and lights the subject from behind. Because contrast tends to be high, judgment of exposure can be difficult in backlit scenes. An average exposure meter reading over the whole scene will often produce over- or underexposure, so it is advisable to take a separate reading for the part of the subject for which the normal exposure is required. Despite these problems, backlighting can be used creatively to produce, for example, pure silhouetted shapes or a halo effect around a sitter's head in portraiture.

Back projection
A technique of projecting an image onto the back of a translucent screen to provide a suitable background for a subject placed in front of it. Considerable skill is needed to match the foreground subject with the background so that there are no inconsistencies, particularly in lighting.

Barndoors
A set of hinged flaps mounted on the front of studio lights to control the direction and width of the beam of light.

Bottom lighting
A form of lighting in which the principal light source shines from directly below the subject.

Bounce flash
A technique of softening the light from a flash source by directing it onto a ceiling, wall, cardboard or similar reflective surface before it reaches the subject. The light is diffused at the reflecting surface, and light power decreases because of absorption there and because of the greater distance between light source and subject. Bounce flash is used particularly in portraiture, where direct flash is often harsh and unflattering and can cause red eye. If the reflecting surface is colored, it will affect the light, so white surfaces should be used unless special color effects are desired.

Bracketing
A way to ensure accurate exposure by taking several pictures of the same subject at slightly different exposure settings above and below the presumed correct setting. Bracketing is always advisable in unusual lighting conditions.

Cable release
A thin cable encased in a flexible plastic or metal tube, used to release the shutter when the camera is not being handheld. Use of the cable release helps to avoid vibration when the camera is mounted on a tripod or set on a steadying surface for a long exposure. One end of the cable screws into a socket in the camera, often within the shutter release button; the other end has a plunger which fires the shutter when depressed. Some models have locking collars that hold the shutter open for long exposures. There is also a pneumatic type of release, operated by an air bulb and fitted with a long cable for remote-control work, including self-portraiture. An air release is less liable to wear through friction, but will perish with age.

Cast
An overall tinge of a particular color in a print or transparency. Color casts often occur when the light source illuminating the subject of a photograph is not matched to the film.

Color correction filter
Comparatively weak color filter used to correct for small differences between the color temperature of the illumination used for a particular exposure and that for which the film was manufactured. An 85B filter is used with tungsten film in daylight, an 80A filter with daylight film in tungsten light. The term is also sometimes rather loosely used to describe the cyan, magenta and yellow filters that are placed in an enlarger to balance the color of prints made from color negatives.

Color temperature
Term describing the color quality (particularly the redness or blueness) of a light source. Color films have to be matched to the prevailing color temperature when accurate colors are required. Daylight and flash have a higher color temperature than tungsten light, which is more orange in quality.

Daylight-balanced film
Film balanced to provide accurate colors when exposed to a subject lit by daylight, that is to say when the color temperature of the light source is around 5,500k. Daylight film is also suitable for use with electronic flash.

Depth of field
The zone of acceptable sharpness in a picture, extending in front of and behind the plane of the subject that is most precisely focused by the lens. You can control or exploit depth of field by varying three factors: the size of the aperture; the distance of the camera from the subject; and the focal length of the lens. If you decrease the size of the aperture, the depth of field increases; if you focus on a distant subject, depth of field will be greater than if you focus on a near subject; and if you fit a wide-angle lens to your camera, it will give you greater depth of field than a normal lens viewing the same scene. Many SLRs have a depth of field preview control – a button that closes the lens diaphragm to the aperture selected for an exposure so that the depth of field in the image can be checked on the viewing screen first.

Dichroic filter
A special type of filter used mainly in color enlargers, allowing very precise control of the specific wavelengths (and hence colors) of light that are allowed to pass through it. Dichroic (two-colored) filters are so called because when they are viewed from different angles their color changes between two predominant hues. They are more expensive than conventional filters, but in addition to their precision they have the advantages of being extremely durable and resistant to fading.

Diffused light
Light that has lost some of its intensity by being reflected or by passing through a translucent material, such as tracing paper. Diffusion softens light by scattering its rays, eliminating glare and harsh shadows, and is therefore of special value in portraiture.

Effects light
A light introduced into a picture for a specific creative effect, rather than as part of the overall lighting scheme.

Emulsion
The light-sensitive layer of a film. In black-and-white films the emulsion usually consists of silver halide crystals suspended in gelatin, which blacken when exposed to light and treated with chemicals. The emulsion of color films contains molecules of dyes in addition to the silver halides.

Exposure
The total amount of light allowed to pass through a lens to the film, as controlled by both aperture size and shutter speed. The exposure selected must be tailored to the film's sensitivity to light, indicated by the film speed rating. Hence overexposure means that too much light has created a slide or print that is too pale; underexposure means that too little light has resulted in a dark image.

Exposure meter
An instrument for measuring the intensity of light so as to determine the shutter and aperture settings necessary to obtain correct exposure. Exposure meters may be built into the camera or be completely separate units. Separate meters can sometimes measure the light falling on the subject (incident reading) as well as the light reflected by it (reflected reading); built-in meters measure only reflected light. Both types of meter may be capable of measuring light from a particular part of the subject (spot metering) as well as taking an overall reading.

Extension attachment
A camera accessory used in close-up photography to increase the distance between the lens and the film, thus allowing you to focus on very near objects. Extension rings are metal tubes, usually sold in sets of three, and can be used in different combinations to give various increases in lens–film distance. Extension bellows are continuously variable between the shortest and longest extensions. These are more cumbersome than tubes, and need to be mounted on a tripod.

Fast lens
A lens of wide maximum aperture, relative to its focal length, allowing maximum light into the camera in minimum time. The speed of a lens – its relative ability to take in light – is an important measure of its optical efficiency; fast lenses are harder to design and manufacture than slow lenses, and consequently cost more.

Fill-in light
Additional lighting used to supplement the principal light source and brighten shadows. Fill-in light can be supplied by redirecting light with a white cardboard or metal foil reflector, as well as by supplementary lamps or flash units.

Film speed
A film's sensitivity to light, rated numerically so that it can be matched to the camera's exposure controls. The two most commonly used scales, ASA (American Standards Association) and DIN (Deutsche Industrie Norm), are now superseded by the system known as ISO (International Standards Organization). ASA 100 (21° DIN) is expressed as ISO 100/21° or simply ISO 100. A high numerical rating denotes a fast film, one that is highly sensitive to light and therefore ideal in poor lighting conditions.

Filter
A thin sheet of glass, plastic or gelatin placed in front of the camera's lens to control or change the appearance of the picture.

Flash
A very brief but intense burst of artificial light, used in photography as a supplement or alternative to any existing light in a scene.

Flash exposure meter
An exposure meter designed to read only the light from flash sources and ignore all other types of light. The photographer holds the meter close to the subject and points it at the flash, which when fired causes a needle to swing across a scale or one of a series of diodes to light up on the meter. This indicates the correct aperture to set on the camera.

Frontlighting
A form of lighting in which the principal light source shines from the direction of the camera toward the subject.

Front projection
A technique of projecting an image onto the front of a screen to provide a suitable background for a subject placed in front of it. This can be done with an ordinary slide projector or, more easily, with a special front projection unit, which eliminates unwanted shadows.

Gelatin
A translucent flexible material used to make photographic filters. Gelatin is also used as the binding agent for the grains of silver halide in photographic emulsions.

Guide number (flash factor)
A number used to refer to the power of a specific light source. Dividing the guide number by the flash-to-subject distance yields the correct aperture to set at a given film speed.

Hard light
Strong, direct light that has not been diffused in any way. Hard light produces sharp, dense shadows and models forms clearly. It makes strong colors appear more brilliant and weakens pale colors.

High key see KEY

Highlights
Bright parts of a subject that appear as the densest parts on a negative and as the lightest areas in a print or slide.

Hotshoe see ACCESSORY SHOE

Joule
A unit of energy equal to one watt-second. In photography, the term is used to indicate the output from an electronic flash unit.

Key
A term describing the prevailing tone of a photograph. "High key" refers to a predominantly light image: "low key" refers to a predominantly dark one.

Large-format camera (view camera)
Camera producing large images – negatives or transparencies 4 × 5 inches or larger. Large-format cameras are very simple in construction. A front panel holds a lens, shutter and iris diaphragm; a bellows links this front panel to the rear panel, which contains a ground-glass screen used for focusing. Focusing is accomplished by moving front and rear panels closer or farther apart. Immediately prior to exposure, the photographer replaces the ground-glass screen with a sheet of film. A special box-shaped holder protects the sheet of film from light until the film is inside the camera.

Latitude
The ability of a film to record an image satisfactorily if exposure is not exactly correct. Black-and-white and color print films have more latitude than color transparency films, and fast films have greater latitude than slow ones.

Light tent
A wire frame covered with plain white diffusing material, used to enclose a small object completely and diffuse the light that reaches it to create a soft, shadowless effect. The camera lens projects through a small opening cut in the drapery.

Long-focus lens
A lens that includes a narrow view of

the subject in the picture frame, making distant objects appear closer and magnified. Most long-focus lenses are of the type known as telephoto lenses. These have an optical construction that results in their being physically shorter than their focal length, and consequently easier to handle than non-telephoto long-focus lenses. In fact, almost all long-focus lenses are now telephoto lenses, and the two terms tend to be used interchangeably. Long-focus lenses are useful even in a studio, because they can produce flattering portraits.

Low key see KEY

Macro lens
Strictly defined, a lens capable of giving a 1:1 magnification ratio (a lifesize image), but generally a term applied to any lens specifically designed to focus on subjects very near to the camera.

Medium-format cameras
Cameras that take rollfilm and produce a negative or transparency that is up to four times the area of a 35mm frame; the most popular format is $2\frac{1}{4} \times 2\frac{1}{4}$ inches. Medium-format cameras offer a compromise between the image quality of a large-format camera and the compactness and versatility of a 35mm SLR camera. They can be handheld, and are often used in fashion photography.

Mired
A unit of color temperature used to calibrate color correction filters.

Modeling light
A tungsten lamp mounted close to the flash tube of a studio flash unit. The continuous illumination of the modeling light simulates the effect that will be produced by the instantaneous burst of the flash, and is thus useful for previewing the lighting of a picture.

Motordrive
A battery-operated device that attaches to a camera and automatically advances the film and retensions the shutter after an exposure has been made.

Off-camera flash
Small flash unit linked to the camera with an electrical lead. Off-camera flash enables you to create more varied lighting effects than does a flashgun fitted to the hotshoe of the camera.

Photolamp
A tungsten light bulb specially designed for photographic use. Photolamps are similar to household bulbs, but bigger and brighter. They give off light that is matched to tungsten-balanced film.

Red eye
The bright red color of the pupil of the eye that sometimes disfigures pictures taken by flash. It is caused by reflection of the flash unit's light from layers of the retina rich in blood vessels. Red eye can be avoided by making sure the subject is not looking directly at the camera or by using off-camera or bounce flash.

Reflector
Any surface capable of reflecting light; in photography, generally understood to mean sheets of white, gray or silvered cardboard used to reflect light into shadow areas. Lamp reflectors are generally dish-shaped mirrors, with the lamp recessed into the concave interior, which points toward the subject. Studio electronic flash equipment is often combined with an umbrella reflector, usually silvered, mounted on a stand.

Rimlighting
A form of lighting in which the subject appears outlined with light against a dark background. Usually, the light source in rimlit pictures is above and behind the subject, but rimlit photographs can look quite different from conventional backlit images, in which the background is usually bright.

Ring flash
A circular flash unit fitted around the lens, used for even, shadowless lighting in close-up photography and sometimes in portraiture.

Sidelighting
A form of lighting in which light falls on the subject from one side. Sidelighting produces dramatic effects, casting long shadows and emphasizing texture and form.

Snoot
A conical attachment fitted to a studio light to concentrate the beam.

Soft focus
Deliberately diffused or blurred definition of an image, often used to create a dreamy, romantic look in portraiture. Soft-focus effects are often achieved with special filters, engraved so that the glass surface breaks up the light by means of refraction.

Soft light
Light that has lost its intensity by being diffused or reflected. Soft light produces weak shadows and reveals fine detail and textures.

Spotlight
A photographic lamp designed to emit a concentrated beam of light.

Tungsten halogen lamp
Type of tungsten lamp in which the glass envelope through which the filament runs contains a halogen gas (usually iodine and/or bromine). The halogen enables the lamp to maintain its color quality throughout its life by preventing vaporized tungsten from migrating to the envelope and thereby causing blackening.

Tungsten light
A common type of electric light for both household and photographic purposes, named after the filament of the metal tungsten through which the current passes. Tungsten light is much warmer in color (more orange) than daylight or electronic flash, and with daylight-balanced slide film you must use a blue filter to reproduce colors accurately. Alternatively, you can use special tungsten-balanced slide film.

Window light
A studio flash unit with a built-in diffuser in the form of a rectangular acrylic sheet.

Index

Page numbers in *italic* refer to the illustrations and their captions.

Acrylic backgrounds, 54; *6, 8, 55*
Animals, sets for, 64; *64, 65*

Back projection, 62–3; *63*
Background papers, 52, 54; *52, 53*
 storage, 22
Backgrounds, 6, 51–65
 child portraiture, 74; *74, 75*
 elaborate sets, 60; *60, 65*
 group portraits, 72; *72, 73*
 lighting, 53; *32, 41*
 patterned, 56; *56*
 plain, 52-3, 54; *52–5*
 projected, 24, 62–3; *25, 63*
 simple sets, 58; *58, 59*
 still-lifes, 54, 56; *54, 55, 56*
 textured, 56; *56*
Backlighting, 38, 54, 78; *15, 39*
Barndoors, *37, 43, 78*
Black-and-white film, 40

Candid shots, 72
Ceilings, studios, 18, 22
Children, portraits, 74; *74, 75*
Close-ups, *12, 43*
Color, still-life, 84; *32, 84, 85*

Darkrooms, 18; *18*
Daylight-balanced film, 48; *61*
Daylight studios, 48; *48, 49*
Diffusers, 12, 32, 36, 48; *33, 34, 36, 39*
Diffuse lighting, 32, 36, 44, 49, 78; *36, 37, 44, 45, 46, 48*
Dressing areas, 18, 24; *18*

Effects lights, 34
Electronic flash, 30, 36; *30–1*

Fashion photography, 76; *76, 77*
 studios for, 24
Fill-in lighting, 32, 34; *38*
Film, daylight-balanced, 48; *61*
 latitude, 40
 tungsten-balanced, 28
Filters, 48
 dichroic, *29*
 for tungsten light, 28
Fish, photographing, 64; *64*
Flash, 6, 30; *8, 30–1*
 portable, 90
 ring, 90; *91*
Flash meters, *30*
Floodlamps, 42
Flowers, 94; *94*
Food photography, 24, 96–7, 98; *17, 25, 96–9*
Framing, portraits, 68; *68, 69*
 still-lifes, 82
Frontlighting, 38; *38*
Front projection, 24, 62–3; *25, 63*

Glass, photographing, 38, 64, 86; *36, 38, 39, 47, 86, 87*
Group portraits, 72; *72, 73*

Hard lighting, 42, 78; *42, 43*
High key, 46
Highlights, adding, 36, 40, 42; *8, 17, 25, 32, 36, 37, 40, 41, 48*

Illusions, 88; *85, 86, 87, 88, 89*
Incident light reading, 46; *35*

Jewelry, 92; *92, 93*

Lenses, angles of view, *19*
 for portraits, 18; *19*
 for still-life, 18
Lighting, 6, 27–49
 arranging, 38, 40; *38–41*
 backgrounds, 49, 53; *35, 41*
 backlighting, 38, 54; *39*
 barndoors, *37, 43, 78*
 bottomlighting, 38
 child portraiture, 74; *74, 75*
 daylight, 48; *48, 49*
 diffuse, 32, 36, 44, 48, 78; *36, 37, 44, 45, 48, 49*
 effects light, 34
 fashion photography, 76
 fill-in, 32, 34; *10*
 flash, 30; *30–1*
 frontlighting, 38; *38*
 hard, 42, 78; *42, 43*
 modeling, 30; *15, 17*
 multiple sources, 34; *34–5, 47*
 nude photography, 78; *78*
 one-lamp lighting, 32; *32–3*
 portraiture, 32, 40, 42, 44, 46, 48; *40–1, 45*
 reflectors, 32, 34, 36, 40; *36, 37*
 rimlighting, 34; *10, 34*
 sets, 58, 60; *59*
 shadowless, 46; *46–7*
 silhouettes, 32, 38; *33, 39*
 small objects, 90
 soft, 44; *44, 45*
 stands for, 20
 still-lifes, 38, 82; *38, 39, 82, 83*
 transparent objects, 86; *86, 87*
 tungsten, 20, 28, 36; *28, 29*
Light tent, 46, 92; *47*
Living rooms, as studios, 20; *20*

Mirrors, *10, 22*
 highlighting with, *17, 20*
Modeling lights, 30; *15, 17*
Models, and makeup, *25*
 fashion, 76; *77*
Motion, freezing, 30; *8, 30*
Multiple lighting, 34-5; *34, 35, 47*

Nude photography, 78; *78*

Pegboards, 22; *22*
Plants, 94; *94, 95*
Portraits, 46, 67–79; *15*
 backgrounds, 53–4, 56; *53, 54*
 children, 74; *74, 75*
 close-ups, *35*
 full-length, 70; *70, 71*
 groups, 72; *72, 73*
 half-length, 68
 head-and-shoulders, 68
 lenses for, 18; *19*
 lighting, 20, 32, 40, 42, 44, 46, 48; *33, 40–1, 45*
 and movement, 76; *77*
 pairs, 72; *72, 73*
 soft lighting, 44; *20, 45*
 studios for, 18
 tightly framed, 68; *68, 69*

Projection, back, 62–3; *63*
 front, 24, 62–3; *25, 63*
Props, 58, 70, 76; *71*
 flowers and plants, 94
 portraits, 70

Reflections, *10, 86*
 dulling, 92
 lighting, 32, 34, 36, 40; *36, 37*
Reflectors, 34, 36, 40, 44, 74, 86, 92; *8, 20, 37, 39, 40, 47, 74, 75*
 stands for, 20
Rimlighting, 34; *10, 34*
Ring flash unit, 90; *91*
Room sets, 60

Screens, projection, 62–3
Sets, 58, 60, 64; *58–61, 64*
 captive, 64; *64–5*
 lighting, 58, 60; *59*
 for still-life, 88
Shadows, conflicting, 34
 diffuse light and, 36
 filling in, 32, 34
 hard lighting, 42
 shadowless lighting, 46; *46, 47*
Sidelighting, 38; *38, 42*
Silhouettes, 32, 38, 78; *33, 39*
Snoot 42; *37, 41, 43*
Soft lighting, 44; *44, 45*
Space, planning, 18; *18, 19*
Spotlights, 34, 42, 53; *34, 35, 43, 68, 69*
 variable-beam, *29, 32*
Stands, lighting, 20; *45*
Still-life, 6, 81–98; *12, 17, 48*
 backgrounds, 54, 56; *54, 55*
 color, 84; *84, 85*
 compositions, 82; *82, 83*
 flowers, 94; *94*
 food, 96–7, 98; *17, 25, 96–9*
 jewelry, 92; *92, 93*
 lenses for, 18, 38
 offbeat, 88; *88, 89*
 plants, 94; *94, 95*
 small objects, 90; *90, 91*
 studios for, 18, 22
 transparent objects, 86; *86, 87*
Studio flash units, 30; *17, 30–1*
Studios, 17–23
 ceilings, 18, 22, 24
 daylight, 48; *48, 49*
 equipment, *22–3*
 lighting, 27–49
 permanent, 22; *22–3*
 planning, 18; *18, 19*
 professional, 24
 specialized, 24
 storage, 20, 22; *18*
 temporary, 20; *20*
 walls, 22

Textured backgrounds, 56; *56*
Three-dimensional sets, 51, 58, 60; *58, 60, 61*
Transparent objects, 86; *86, 87*
Tungsten-balanced film, 28
Tungsten-halogen lamps, 28, 29
Tungsten lights, 20, 28, 36; *28, 29*

Umbrella reflectors, 44; *37, 74*

Window light, *37*

Acknowledgments

Picture Credits
Abbreviations used are: t top; c center; b bottom; l left; r right.
Other abbreviations: DTCL for Daily Telegraph Colour Library, IB for
Image Bank, SGA for Susan Griggs Agency and TWPL for Trevor Wood
Picture Library.

Cover Henry Groskinsky

Title Bob Croxford. **7** Julian Nieman/SGA. **8** TWPL. **9** Al Satterwhite/IB.
10 Nancy Brown/IB. **11** Graeme Harris. **12** Michael Freeman. **13** Michael
Freeman. **14** Jacques Joffre/Explorer. **14-15** Gatti Tullio/IB. **16-17** Michael
Freeman. **24** John Hedgecoe. **25** t Michael Freeman, br John Hedgecoe.
26-27 Charlie Stebbings. **28** Charlie Stebbings. **30** l Steve Bicknell, r
Akira. **32** l Michael Melford/IB, r Graeme Harris. **33** t Helen Pask, b
TWPL. **34** Tony Stone Associates. **35** t Gered Mankowitz/Rembrandt
Bros Photo Studios, b Pete Turner/IB. **36** all Michael Freeman. **37** Chris
Thomson. **38** all Michael Freeman. **39** all Michael Freeman. **42** t Al Sat-
terwhite/IB, b Olivier Garros/Fotogram. **43** Graeme Harris. **44** Bert
Bell/DTCL. **45** t Graeme Harris, b Michael Boys/SGA. **46** Anthony
Crickmay/DTCL. **47** t Hideki Fujii/IB, b Julian Nieman/SGA. **48** Michael
Freeman. **48-49** TWPL. **49** all TWPL. **50-51** R. Gunter/Explorer. **52** Neill
Menneer. **53** l Tim Clinch, tr Jan Cobb/IB, br Akira. **54** l Nick Boyce,
r Graeme Harris. **55** t Peter Phillips/TWPL, b Al Satterwhite/IB. **56** l
Charlie Stebbings, r Steve Bicknell. **57** John Garrett. **58** all Steve Bick-
nell. **59** Peter Williams. **60** Steve Bicknell. **61** t Sanders Nichol-
son/DTCL, b Peter Williams. **62** Bob Elsdale, Focalpoint Studios-Ken
Shirley/Interphoto Pic. Lib. **63** Bob Elsdale, Focalpoint Studios-Simon
Thornley/Tony Stone Associates. **64** t Michael Freeman, b Stephen
Dalton/NHPA. **65** Tony Stone Associates. **66-67** Chris Barker. **68** l Ian
Miles/IB, r Steve Nieborf/IB. **69** t Akira, b Will McBride/IB. **70** Richard
Dudley-Smith. **70-71** Richard Dudley-Smith. **71** Gillian Campbell. **72** Jill
Furmanovsky. **73** t Gillian Campbell, b Jill Furmanovsky. **74** Richard
Stradtmann/IB. **75** t John Garrett, b Graeme Harris. **76** Ian Miles/IB. **77**
tl and tc Gillian Campbell, tr Akira, b Chris Thomson. **78** l Hideki
Fujii/IB, r Tony Stone Associates. **79** Pete Turner/IB. **80-81** Charlie Steb-
bings. **82-83** Charlie Stebbings. **83** t Bob Croxford, b Peter Williams. **84**
t Lou Jones/IB, b Julian Nieman/SGA. **85** Peter Williams. **86** l Peter
Williams, r Steve Bicknell. **87** Peter Williams. **88** Steve Bicknell. **88-89**
Charlie Stebbings. **89** Peter Williams. **90** t James H Carmichael Jr/IB. **90-
91** Michael Boys/SGA. **91** Tony Stone Associates. **92** t Neill Menneer, b
Steve Bicknell. **93** Peter Williams. **94** all Simon Yeo. **95** Steve Bicknell.
96 l Larry Dale Gordon/IB. **96-97** Tessa Traeger. **97** t Tessa Traeger, b
Peter Williams. **98-99** all Roger Phillips.

Additional commissioned photography by Michael Freeman, John Miller,
George Taylor

Artists Gordon Cramp, Tony Graham, John Hutchinson, Coral Mula,
Andrew Popkiewicz

Retouching Bryon Harvey

Kodak, Ektachrome, Kodachrome and Kodacolor are trademarks